Maurice Caldera was born in Madrid in 1968 and grew up in Australia and the UK.

The Double Life of Daniel Glick is his first novel. He is currently living in London and working on his second novel.

Maurice Caldera

The Double Life of Daniel Glick

Dedalus

Published in the UK by Dedalus Ltd,
Langford Lodge, St Judith's Lane, Sawtry, Cambs, PE28 5XE
email: DedalusLimited@compuserve.com
www.dedalusbooks.com

ISBN 1 903517 27 3

Dedalus is distributed in the United States by SCB Distributors,
15608 South New Century Drive, Gardena, California 90248
email:info@scbdistributors.com web site: www.scbdistributors.com

Dedalus is distributed in Australia & New Zealand by Peribo Pty Ltd,
58 Beaumont Road, Mount Kuring-gai N.S.W. 2080
email: peribo@bigpond.com

Dedalus is distributed in Canada by Marginal Distribution,
695, Westney Road South, Suite 14 Ajax, Ontario, LI6 6M9
email: marginal@marginalbook.com web site: www.marginalbook.com

First published by Dedalus in 2004

The Double Life of Daniel Glick copyright © Maurice Caldera 2003

Printed in Finland by WS Bookwell
Typeset by RefineCatch Ltd, Bungay, Suffolk

One

That day I felt sick. I counted the minutes till the end of the day, they were long and dull and I wanted them gone. Perhaps I was just bored. I asked my boss if I could go home, but he said that I should hold on for as long as I could. He didn't even look up from the papers spread before him on his desk; he was hunched over them as though I was trying to copy his answers in an exam. I went back to my own desk and held on until the end of the day, and I left when everybody else left, just like I would have on any other day.

My boss's name is Mr Ferrer, but we all had to call him by his first name, his first name is Daniel. He only became our boss because the one before him died in the earthquake, his name was Mr Banos, and I bet you that he would have let me go home if I had told him that I wasn't feeling well, he would have put down what he was doing at that very moment and he would have asked me what was wrong. The block of flats where Mr Banos lived collapsed on top of him and there was only one survivor. A few of us from work went to see the building, and it was hard to believe that even one person had survived, the top floor was completely intact, but the other five storeys were squashed underneath it, neatly folded like an accordion shut tight.

Mr Ferrer was tall and thin and looked a lot older than he was, he wore white shirts that were so worn and so old that you could see right through them, I swear you could actually see the darkness of the hair on his chest right through the material of the shirt, and his teeth were crooked and brown, like the pictures of teeth in the dentist's waiting room that show you how your teeth will end up if you don't look after them.

My name is Daniel Glick and I didn't really talk to many of the people in the office because you couldn't really trust any of them. There was one man who I got to know because we both started working there on the same day, we met up in the

canteen and had lunch together for the first few weeks until we got to know the other people who worked with us, and then we had lunch with them instead. His name is Daniel as well, and at first we laughed about the fact that there were three of us with the same name, but then it just became annoying rather than funny and nobody joked about it any more. After awhile he was promoted to a job on the third floor and he ate by himself in the canteen, and we hardly exchanged a word after that.

That day the people in the train on the way home were stuffed in like matches in their box, the way they are every night, the air was thick with their smell and their breath and it made me feel sick for real. At last I reached my stop, and at last I could breathe. I stood on the escalators that rolled up into the street, and the further up they went the more blinding the daylight seemed, as though I had spent the whole of the day under the ground. The pavement outside the station was covered in leaves that crunched under my feet as I walked home, the leaves left on the trees were either red or yellow or brown, some of them hovered in midair like the magic carpets in the stories my mother used to read to me when I was a child. Every day those leaves were collected and incinerated in large metal bins, the smell of burning leaves made its way into every room in every house in the city, and still the ground was covered in them, and still they crunched under my feet with every step that I took.

I pushed the heavy metal door of the entrance to the block of flats where I live. As always it was dark inside and I stepped cautiously until my eyes began to adjust to the darkness, and I could let go of the banister and make my way up the stairs unaided.

Someone was walking up the stairs ahead of me, I could hear them huffing and puffing, and I could hear the stairs creaking as they shifted their weight from one leg to the other. In the wintertime the old people living in the building walked up and down the stairs for exercise, my grandfather used to do it along with all the other old people, and at times the stairs were crowded with pensioners walking up and down silently,

as though it was a punishment, and you had to squeeze past them as you made your way up or down. On that particular day it was Mrs Roman who was walking up the stairs, and she only realised that there was someone behind her at the very last moment.

'What do you want?' she said to me, as though I was sneaking up on her.

'It's me, Daniel.'

Mrs Roman was old and forgetful, and since her husband had died her memory had deteriorated so much that sometimes she didn't even know what day of the week it was. 'My husband walked up these stairs three at a time,' she said, 'he was tall and strong and he'd knock you down to the ground if he heard you talking to me like that.' Mrs Roman seemed to have her husband mixed up with somebody else, he was tall just like she'd said, but he wouldn't have knocked anyone down to the ground, he wouldn't have hurt a fly. Mr Roman had a stutter that was so bad that sometimes he couldn't even finish his sentences, and my grandfather used to make fun of him in front of everybody, even though they were the best of friends.

'How have you been keeping Mrs Roman?' She pulled herself up onto the next step, already out of breath from all the exertion of the steps that had come before and all the words that she had just spoken, and you didn't have to know her to see that she didn't have long left; she looked thinner and paler than I'd ever seen her, her hair was dirty and knotted like the hair of an old doll lost at the bottom of a trunk in the attic, and she wore her dressing gown all day long because she couldn't be bothered to put any clothes on. 'You should take a walk outside in the sun.' I spoke louder so that she could hear me, and my words echoed up and down the stairs to all the other floors and back again, but Mrs Roman, who was standing right next to me didn't catch a single word, she stopped for a moment and looked around her, as though she had heard something but couldn't quite make out what, then she went back to concentrating on taking one step at a time, and all I could do was follow behind her until I reached the third floor which was where I lived. Mrs Roman still had two more

floors to go, she raised her arm in the air and the old flesh underneath it dangled from side to side as she waved me off, and it seemed that perhaps she had recognised me after all.

That was the day that Marina had left for good. I realised she wasn't there any more from the moment I closed the door behind me, I looked into each of the rooms and she wasn't there, and her things weren't there, and she would never come back again, and maybe that's the reason why I had felt sick that day at work.

She'd been taking her things from the flat bit by bit, all the things that she had brought with her after we were married were slowly making their way out again, bit by bit so that I wouldn't know. At first it was little things and I didn't notice they were gone, but then every day there was something else I couldn't find; towels and plates and soap, and things that now I can't even remember, things that you never think about until they're not there any more. Every night whilst she was busy peddling at her sewing machine, I crept away into the bedroom, opened her drawers and looked through her things, and every night there were fewer and fewer things there; her drawers were half full and the metal coat hangers that had once strained with the weight of all her clothes now hung spare, and clinked against one another when I opened the door of the wardrobe, and still she didn't say a thing and I didn't dare ask her. The dolls that Marina had brought into the flat and that she sat up against the pillows every morning without fail after making the bed, watched me going through her things night after night, they were sat up straight with their arms bent unnaturally by their sides, looking more terrified than usual.

But even the dolls began to disappear one by one, first the little ones that sat in-between the bigger ones because they were too small and lifeless to sit up by themselves, and then the bigger ones, the ones that looked like real little girls, and have real eyelashes like little girls, and whose eyelids can shut when you lie them on their back, and still Marina said nothing.

For days I thought about nothing else, I sat at my desk staring out into space wandering what she could possibly be

up to, until I couldn't contain myself any longer, I stepped into Mr Ferrer's office and asked for his permission to go home, he scratched at his papers, then at the blond and ginger bristles on his face, and took a long breath like he was about to speak, but he took so long to say anything that I thought he was about to sneeze rather than speak. His office was tiny, and instead of a door it had a pair of curtains that he could close for privacy, they were old and worn just like the shirts he wore, and even though you couldn't see through them, you could hear every word that was said on the other side. Finally Mr Ferrer spoke, 'close the curtains for me will you.' The sound of typewriters died down all around us, and I knew that everybody in the office would be listening to whatever Mr Ferrer had to say. 'Maybe you've forgotten that you work for the government, and the things you do will affect every single person in the country.' I nodded my head, although I doubted that it would affect one person let alone every person in the country. 'That's why you should come to me if you have any problems and tell me the same as you would tell your own brother.'

His words were wasted on me, I didn't have a brother or a sister, or a mother, or a father, I just had a wife who hardly said a thing to me and who was clearing the whole place of all her possessions, and I was never usually sick, but he had to make a meal of it because he liked to watch me squirm. 'It's nothing serious,' I said to him, 'it's just that I don't feel very well today, I think I've got a bit of a temperature,' I put the palm of my hand up to my forehead, 'but I promise you if it was anything serious I would tell you straight away.'

Mr Ferrer chewed at his pen the whole time I was speaking and he took it out of his mouth once I'd finished, like it was a thermometer and he was checking his own temperature, when really he was just checking to see if there was any pen left to chew. He used the same chewed up pen to point at the door as a gesture for me to go, I didn't wait for another word or a sneeze or anything else, I pulled back the curtains and got out of his office as quickly as I could before he changed his stupid mind. The sound of typewriters started up again,

everybody watched me as I buttoned my jacket, they watched without looking.

But the woman at the desk next to mine, who wears her coat all day long and never says a word to anybody, had noticed that I was restless on that day. 'What's wrong with you? You're like a monkey today, you're so unsettled.' She was a small, quiet, frail woman who seemed older than she was and never usually said a thing. She only gave one word answers when she was spoken to, and mostly you forgot that she's there at all, but that day she did speak, and everybody listened, because she never usually said a thing. I told her that I was all right and carried on with my work, and I said to myself that I should stop fidgeting in my seat, but I must have mumbled the words out loud and not just thought them in my head. 'What did you say?' she asked.

'Nothing.' I looked back down at the papers on my desk.

So everybody watched me when I walked into Mr Ferrer's office, and they watched me as I buttoned up my jacket and packed up my things, and they all knew that there was something not right on that day, and I knew that Mr Ferrer would ask them about me, and I knew that they would tell him without hesitation because that's how things are in that office.

I was like a monkey, just like that woman had said. I walked up and down the platform from one end to the other end as I waited for the train, and when it did arrive, I stood up all the way, holding on to the metal bars above my head, letting them take the weight of my body, just like a monkey swinging from the trees.

There were few people out on the streets, everybody was either at work or at school or exactly where they were supposed to be. I took a seat in a small bar in the same street that I live in, from which you could see the flat without even straining your eyes. My grandfather used to go drinking there and many times I had walked past the bar and seen him from the street, but the only time that I had ever gone inside was after the earthquake when I had gone out looking for him everywhere that I could think of. Sometimes at night on a Friday or a Saturday you can hear the men inside the bar

playing cards and talking loudly, and sometimes when they leave they bring their singing or their arguments out onto the street, until they arrive at their homes, or until somebody throws a bucket of dirty water over their heads, which sometimes makes them only sing louder.

There was nobody in the bar that day except the man who worked there, a young man, younger than me, with short hair, his elbows were resting on the counter, and his head was being held up by his hands, as if to stop it falling off his head and rolling onto the ground like a ball. I sat down at a table by the window so that I could see out into the street, and the barman came out from behind the bar, dragging his feet as though he had hauled himself from the other side of the world. When I asked him for a coffee he just stood there like he hadn't heard, and stared out of the window for a moment or two before dragging himself back to the other side of the world, where he'd just come from.

All the tables in the bar were covered with plastic tablecloths so that they could be easily cleaned, but no one had actually bothered to clean them, and so they were covered in crumbs and the sticky stains of spilt drinks, a few flies patrolled those tables, and their buzzing was the only sound that you could hear in the bar on that day. The chairs around the tables were the sort you can fold away, they were made of metal and had the name of a local beer written in red across the backrest, on some of them the name was almost worn out from all the times that people had sat in the bar and leaned back to drink their beer. The barman brought the coffee and stood over me until I fished around in my pockets for some coins, so that he wouldn't have to come back for it. Outside in the street nothing happened, the coffee had come, cooled down and been drunk, and I was about to ask for another one, when I saw Marina leave the building to take out the rubbish. She held a plastic bag in her hand and I saw her walk towards the bins, but she didn't stop at the bins, she just kept on going and only stopped when she got to a black car parked further down the street that looked new and shiny. I had to move my chair to the other side of the table so that I could see what she was up to.

She placed her hand under the metal of the boot, opened it up, dropped the bag inside, then closed the boot, which took her four attempts. She looked so little next to the car. She walked back to the block of flats and I didn't see her come out again.

Inside the car there was a man smoking a cigarette, all I could see of him was his short dark hair and the smoke that rose in sudden puffs through the open window of the car. For a moment the smoke hovered above the car as though it was unsure where to go, and then it was dispersed by the little air that there was on that day. Other than that, the man didn't move, and after a while the car drove off. That's all I saw.

I moved round to where I had been sitting before, the lazy barman was no longer at the bar but standing right behind me, leaning against the wall with his arms folded. 'She does the same thing every day, same time, same car.'

'Whose car is it?' My voice was shaky, and I had that pang in my stomach that you get when you are scared or excited.

'Fuck knows.' He moved away from the wall and took the empty cup and saucer from my table, 'Another coffee for you?' he asked.

'I'll have a beer this time.' I said.

The barman seemed a little happier than before, perhaps because opening a bottle of beer would be less of a strain than making a coffee, and when he walked to the bar he didn't drag his feet like he had done before. 'She won't come out again now.' He pulled the top off the bottle of beer and it rolled out onto the floor behind the bar to a spot where he couldn't see it, and where he wouldn't go looking.

'How do you know that?'

'Because there's nothing else to do here but stare out of that window, and I'm telling you she won't be coming out again.' He came back to where I was sitting and poured out half the beer into a glass, which he placed on the table that shook from side to side because its legs were weak and unsteady. 'I won't be doing this job too much longer I can tell you.'

'What do you think she's doing?' I asked him.

The man shrugged his shoulders and made an ugly face. 'Fuck knows,' he said, 'all I know is that it's the only thing that

happens on this street. What do you care anyway?' I shrugged my shoulders, made a similarly ugly face back at him and took a sip of beer.

The barman began to talk about other things, he was new to the city and new to the job and desperate for conversation, he thought everything was boring, he must have used that word a hundred times, and everything that wasn't boring was expensive, he told me about his spending in great detail, down to what he made in the bar and how much he sent his parents every month. But all I could think about was Marina. He brought me another beer as soon as I finished the first, and the more beers I had the happier he became, as though the alcohol was going to his head and not mine. When he smiled you could see his teeth were all crooked and crammed into his mouth, and they leaned over each other backwards and forwards, this way and that, like old forgotten gravestones in a cemetery.

More people came into the bar, some of them knew the barman by his first name and some of them actually seemed to like him. He kept bringing me more beers, and I kept knocking them back without even knowing if they were free or if I had to pay for them, but in the end he charged me for all the beers and I had just enough money in my pockets. He took out a bottle of special brandy that he said was from his village, and he poured some into a small glass, all the people in the bar made a toast to something that I can't even remember, and we all drank it down in one go, and he even charged me for that.

By the time I left the bar it was dark outside, I had no more money in my pockets and my legs were weak and unsteady. I held on to the banister at the bottom of the stairs and closed my eyes, but my head started to spin, it spun faster and faster until I had to open my eyes, and only then did the spinning stop, and only then could I climb the stairs, slowly one by one just like the old people who walk up and down for exercise.

Marina was busy at her sewing machine, I could feel the floor vibrate underneath my feet as if there was an earthquake coming. She was making a wedding dress for the daughter of the woman who lives on the floor above. There was so much of

the shiny white material on the floor and on her lap and all around her that she looked like she was actually wearing the dress, and it reminded me of the dress she wore the day we got married, and just like that all the anger I'd felt towards her left me and all I could think about was the day we got married and how beautiful she looked in her dress.

I went to the kitchen and drank two glasses of water, one after the other so that I was breathless after the second one. I cupped my hands under the tap and splashed some water onto my face, and I felt all around me for the towel with which to dry my face, but I knew that I wouldn't find one. 'Where are all the towels?' I went in to show Marina, the water dropped from my face onto my shirt and onto the floor, but Marina didn't even look up, she just pedalled faster and faster, as though she was pedalling away from me on a bike, and all my anger came straight back. 'Look at me Marina, I can't even dry my face, there's not a single towel in the kitchen.' I tried so hard not to sway from one side to the other so that Marina wouldn't know I had drunk so much, but she didn't stop pedalling on the machine, and she didn't look up once.

'You're standing in the light,' she said eventually.

I moved away a little from the light so that she could continue what she was doing. 'Marina if there's something wrong you can tell me the same as you would tell your own brother.' I couldn't believe that I had actually said the same stupid thing to my wife that Mr Ferrer had said to me.

'What's my brother got to do with anything?'

'It's just a way of saying it, that's all.' My words slurred one into the next.

'Well find some other way of saying it and leave my family out of it, I don't go on about your family, do I?'

'All my family died in the earthquake,' I said.

'Can we have one day without you talking about the earthquake, or is that too much to ask?'

'I just want to know what's wrong with you.'

'How can I finish this dress if you keep standing in the light?'

She was right, I had moved a little closer without even realising it. I stepped all the way back to the other side of the

room to be sure that I wouldn't stand in the light again. 'Marina, I can't find anything in this house.' I waited for her to say something but she just kept on feeding the material through the machine, and the needle raced through as it stitched one piece on to another. I moved towards her but this time I didn't care about the light or the dress, I picked up the material that was all around her on the floor and I wiped my face with it until my face was dry. 'What are you doing, you'll ruin it.' She pushed me away from her, and I was so unsteady that it forced me all the way back against the wall, and maybe I shouldn't have had that last brandy, even if it had been free I shouldn't have had it.

'I saw you put things in the back of that car,' I screamed back at her.

'You've gone crazy.' You could see the little blue veins standing out from her neck as she spoke to me.

'Let's go and ask the man in the bar across the street, he sees you do it every day.' I moved back to where she was, took her by the arm and tried to pull her away from the chair in which she was sitting, but Marina seemed to be fixed to the chair, as though she had sewn herself onto it.

'You've been drinking yourself stupid in that old man's bar, I could smell it the moment you walked in.' I pulled her by the arm again. 'Leave me alone, I'm not going anywhere with you,' she screamed.

'You're my wife and this is my house, and you'll do whatever I say.' I yelled at the top of my voice and the people from upstairs banged a shoe or a stick or something on the floor, and I let go of her. Water formed in her eyes and flowed onto her cheeks and some of it fell straight onto the dress.

'She hasn't even tried on the dress and it's already stained with tears.' She rubbed away the tears that had fallen onto the material. 'It'll bring her bad luck and it's your fault Daniel, you bring everyone bad luck.' The material rustled as she held it in her hands.

'That's not true,' I said.

'Yes it is true,' she was still sobbing.

'I promise you that it'll bring her good luck.' I took the

material of the dress, brought it up to my face and kissed it. 'Good luck,' I said. I kissed it over and over and said good luck over and over so that all the bad luck would turn to good. Marina's tears suddenly dried up and instead she looked at me like I'd lost my mind, I took her hand in my own and I kissed it like I had been kissing the dress, and I kept repeating the same words over and over. She tried to pull her hand away from me and shut it tight into a little fist so that I couldn't kiss it any more. I put my hand underneath the material of the dress that she was making, and I felt my way through all the layers until I got under the material of Marina's own skirt and found her bare legs. I pressed my hand between her legs and they shut tight just like her hand had done. I pulled them apart and slowly they gave way, and I could feel the warmth between them, and the hair under her pants, and all the time I was getting more and more excited. Marina began to scream, and with my other hand I covered up her mouth so that no one would hear, and instead her little feet stomped the way that a spoilt child's feet stomp when she doesn't get her own way, but all I wanted was to touch her there between her legs where I knew she liked to be touched. The chair she was sitting on fell back and we both landed on the floor with that beautiful white material all around us. There was a knock at the door. 'Who is it?' I asked.

'If you two don't shut up, I'm calling the police.' It was the voice of the woman who lived upstairs, the one whose daughter's wedding dress was surrounding us.

'You won't hear another sound, I promise.' And sure enough, nothing else was said, we didn't even move until we heard the door to her flat upstairs slam shut, and the floorboards creak as she made her way around the rooms directly above us, and all the time my hand had stayed right there between Marina's legs.

Marina had not only stopped trying to scream, she brought her legs together so that I could pull her pants down and then off under the ruffles of white material, and she spread her legs as wide as she could, then I unbuckled my belt and pulled my trousers and my pants down to my ankles. We were both quiet

apart from our heavy expectant breaths. But I couldn't find my way back between her legs, there was so much white material everywhere that I got lost in it, I was trying to guide myself between her legs and I could almost feel her through the material but I just couldn't get there. 'I'm here, I'm here,' she whispered, as she pulled at the material desperately from one side to the other, like she was she doing the cancan lying on the floor. I was pulling it in other directions, and the more we pulled, the less we knew where we were, it was as though we were miles away from each other when really it was just some stupid white wedding dress that wasn't even finished that separated us, and we were trapped in it like fish caught in a net. The more we pulled, the more it rubbed against my groin, and I just couldn't stop myself, I got more and more excited until I finally came all over the beautiful white wedding dress.

'Same old story,' said Marina, trying to get up.

'I'm sorry, I just couldn't–'

'For a moment I thought it was actually going to happen, like a real husband and wife. What was I thinking?' She pulled her pants back up and threw a glance up at the ceiling. 'Look at what you've done to this dress,' she said, showing me the mess I'd made. 'How do you expect her to walk down the aisle in that? I wouldn't even wipe my arse with it now.' She went into the bedroom, slamming the door shut behind her and she never came out again that night, not even to spit in the sink before getting into bed.

I had met Marina by accident two years before. I met her at a picnic by a lake north of here, just outside the city boundaries, a few weeks after the earthquake. The picnic had been organised for the young people in the government offices and factories, so that we could escape the city for a day. We all got the day off work and Mr Ferrer had to sign a special form in order for me to go, he said that I was only just eligible, and that if I had been a year older he wouldn't have let me go. 'You're not exactly a youngster any more,' he said as he begrudgingly handed back the form which he'd signed.

There were rows of buses and crowds of people in the square in front of the main train station which is busy with people and cars and buses and peddlers at the best of times. Each coach was reserved for a different department or factory, and they were going on excursions to various different places. I walked up and down but didn't see a single person from my office. One by one the coaches started leaving. I climbed aboard the first coach I saw, and showed the driver my form, but he just shrugged his shoulders and told me to get inside, even though I didn't recognise a single face in there and I had no idea where we were going.

It was not quite summer, but the sun reflected against the water in the lake so that I could feel its warmth on my face long after I had returned home that day. You could hire boats and row across to the other side, and you could fish from the banks and feed the ducks that swam on the surface, and sitting by the lake you would never imagine that the city was so close and that it was in such turmoil.

Everyone jumped off the coach and ran towards the water, most people had brought their swimming costumes and soon they were leaping into the lake, and the ducks that were swimming by the shore had to paddle all the way to the middle of the lake so that they wouldn't be disturbed, but even in the middle of the lake the ripples reached them. You could tell that the water was cold because of the looks on people's faces and the noises they made when they jumped in. I didn't go into the water because I didn't have my swimming trunks with me, nobody had said anything to me about swimming. There was a girl who also didn't go into the water, she stood under a tree for shade even though it wasn't that hot, but the sun still found its way through the leaves, and specks of light fell onto her face and her arms and the shiny blue material of her dress, like the spots on a leopard in a zoo. She held her hand above her eyes, like a sailor-boy looking out to sea, and with her other hand she played with the long string of white pearls round her neck that were not pearls at all.

Everyone was jumping in, climbing out, pushing each

other's heads below the surface of the water, and jumping in again in such a way as to make as much of a splash as possible.

'Aren't you going in?' I asked the girl with the fake pearls.

'You must be joking, that water is filthy,' she made a face like she'd just eaten a sour orange, 'you could catch something from swimming in that.'

'I bet it's cold,' I said to her.

'I bet it's full of rats,' she said.

'Looks all right to me.'

She looked at me as though I was mad. 'Well why don't you just jump in then, if you think it looks all right.'

'I didn't bring my swimming trunks with me.'

'Why don't you just go in, in your underwear?' She brought her hand down to cover her mouth so that she could force back a giggle, but it came out all the same.

We stood there for a while without saying a word to each other, watching everyone jumping in and climbing out and jumping in again, and I just wished that I had brought my swimming trunks with me so that I could be in the water with everybody else and not have to make conversation with that girl.

'At least we're out of the city,' I said to her.

'Very observant,' she nodded her head.

'I lost all my family in the earthquake,' I said. She took her hand away from above her eyes and she looked straight at me. 'They never even found the bodies.'

'That's horrible.' She started playing with the string of fake pearls around her neck again, twirling them around her little fingers.

'I joined the volunteer forces so that I could help in whatever way I could, you probably heard about us on the television,' I said.

'I don't know what I'd do if I lost all my family.' She stopped playing with her pearls, and instead put her little fingers through her hair, which was short, just like a boy's. 'Except for my brother, I couldn't care less about him.'

'I helped pull people out from the rubble and saved so many lives that I lost count of how many exactly,' I said.

'How old are you?' she asked.

'Twenty-three,' I said, 'how old are you?'

'How old do you think I am?'

'I don't know.'

'Everyone thinks I look younger than I am,' she said it like she was pleased, 'I'm nineteen.'

'You could be younger,' I said.

'That's what everyone says,' she said, looking pleased.

At that moment somebody jumped into the lake, and made so much of a splash, that the water reached us where we were standing, we both jumped back at the same time, but you could see the small spots where it landed on the dress that she wore. She screwed up her face because she was convinced that the water was dirty and full of rats, and we moved a little further away from the lake so that it wouldn't happen again, and where we would be away from all the others. We sat down together on the grass, she sat in the shade and I sat in the sun. She felt the ground with her hand just to make sure that it wasn't wet before she finally sat down.

'I was at the circus on the day of the earthquake,' I told her.

'I love the circus,' she said.

'I tried to run away to the circus once but I got caught and had to go back home.'

'When I was a little girl I wanted to be the woman who stands on the pony as it rides round the ring.'

'You still look like a little girl.' She looked pleased again. 'Bareback riders they're called,' I said, 'I love all the animals at the circus, I used to have a dog that could do tricks just like the ones at the circus.'

'I wouldn't have a dog, but I'd love to have a horse.'

And each thing that we said lead straight on to another thing, and after awhile we couldn't even hear the people who were in the water laughing and screaming, jumping in and climbing out, even though they were right there in front of us.

Her name was Marina Bordan. She had come to the picnic with her brother because he worked in one of the factories along the river in the city, where the current is so strong that it takes all the waste to the sea faster than any train can take it.

20

That's what they say. Her father worked in the same factory, but he wasn't there because that day was just for the young people. Marina had short hair and big eyes that looked even bigger because she was so little. Everything about her was little apart from her eyes; she had little hands, and a little mouth and her skin was so pale that you could see the blue veins on her neck and along her arms, she looked like one of those little gymnast girls that flip around on mats with ribbons in their hands. She made all her dresses herself, she had even made the dress which she was wearing on that day, it was shiny blue and had a matching jacket that she didn't take off the whole time.

Suddenly we realised that the laughing and the screaming had stopped. We looked towards the lake and there were people coming out of the water, and a crowd was forming on the grass, the man who had been our driver was pushing and shouting at them to get back, he was naked from the waist up, and his hairy belly was bouncing around from all the excitement.

It turned out that one of the girls who came with us had almost drowned. She was lying on the ground by the side of the lake. They had all been splashing around and pushing each other's heads under the water, and a dead mouse had got stuck in the back of her throat as she gasped for air. They said that the dead mouse had been floating on the surface of the water, and nobody had seen it until she took such a deep breath that she sucked it right into her mouth so that all you could see was its long tail dangling from her lips. That's what they said, but Marina and I didn't see anything because we were sitting well away from the water's edge. When they told us what had happened Marina looked at me and I looked at her, she put both hands up to her mouth and then took them away again to speak. 'I told you,' she said, 'sometimes I have premonitions about things.' She put her finger in her mouth and chewed on the nail. 'My mother is exactly the same, she predicts things all the time.' She took her finger out of her mouth and looked at it, all her nails were bitten down to her fingers. 'It's a gift we have,' she said. 'I feel so bad, I should have warned them.' And then she put her finger in her mouth again. 'Wait till I tell my mother about this.' I didn't want to tell her that she hadn't

21

really predicted anything, all she'd said was that there might be rats in the water, and anyway it wasn't a rat, it was a mouse.

The girl was all right in the end, she had somehow managed to pull herself out of the water. Everyone who saw her said that her face went blue, and for a moment they thought she had drowned. The girl's name was Elena, but Marina didn't know her and I didn't know anyone there on that day. They took her back to the city in a taxi and the rest of us stayed behind and that's all everybody talked about for the rest of the day. No one wanted to go back into the water, and in the end, the coach returned to the city much earlier than we had thought. On the way back I sat next to Marina; her brother, Thomas, sat in the back with his friends, and when we arrived back in the city, he went off with them. I walked her all the way home and left her at her door where she took my hand and shook it.

The next day at work I found out that I had got on the wrong bus, everyone else had gone south for a picnic in the forest. I told Mr Ferrer that it wasn't my fault because the driver had said that it was all right, but he thought that I had just taken the day off work, so I told him about what happened with the girl and the dead mouse and he looked at me like I was mad. 'There's always something with you isn't there Daniel?' he said.

'You can go and check if you don't believe me.'

'Don't worry, I'll definitely be checking up on that story,' he said, but I never heard another thing about it.

The following Saturday I met Marina under the equestrian statue in front of the Grand Hotel where everybody arranges to meet, there were so many other people meeting there that I almost missed her. When I finally saw her she shook my hand again, but this time she didn't let go. We held hands almost all day long, they got hot and sweaty but she still didn't let go, and I didn't want her to let go. We strolled around the gardens in front of the former royal palace, and even though it was so soon after the earthquake, there were flowers of many different colours and trees that hid the buildings on either side, many of which were so badly damaged that they were uninhabitable,

and you could almost forget that there had ever been an earthquake at all.

Marina Bordan lived with her parents in a block of flats in the west of the city in a leafy but slightly run-down neighbourhood near the building site of the enormous new parliament building for which they had bulldozed whole streets and neighbourhoods. It was an old apartment block from the last century that was propped up on one side by logs and planks because the building next to it had collapsed in the earthquake. She was the only person I knew who had a room all to herself; it was a tiny little room which she had filled with girlish things. She shared the bed with a family of dolls that had proper clothes and names, just like real little girls, she made all their clothes herself, and they had different outfits for different times of the year, as though they felt the warmth of the summer, and the cold of the winter. One of the dolls was much bigger than the others and she really did look like a real life little girl, her name was Claudia and she was Marina's favourite out of all of them.

Mrs Bordan was just like her daughter, she was small and thin and had hair cut short like a boy's, which she dyed an orange colour. Mother and daughter sometimes went out in the same clothes, they had two dresses that were the same, and a big pink jumper with a rabbit jumping out of a hat on the front that they both wore a lot at home, like two sailor-boy twins. Mrs Bordan worked as a seamstress in a small clothes factory, and she had taught Marina how to make and mend clothes, just like her mother had taught her. Marina's father was the opposite of his daughter, he was so big and so tall that everything looked miniature and toylike next to him, as though it was intended for Marina's dolls and not for real people, cups and cigarettes and cutlery, and everything you could imagine looked small and out of place in his gigantic hands. Marina was closer to her mother than her father and I never even saw her address him in all the time that I knew her. Her brother's name was Thomas and he slept on the sofa in the living room that converted into a bed, he worked in the steel factory with his father and he was never at home. He was

tall like his father and thin like his mother, and even though he was only two years older than Marina you could see that he was going to lose his hair, it fell out and collected on his shoulders and on his back.

Marina and I were married in a room in the town hall, less than six months after we'd met. Outside in the square, old women sold flowers and prayers of good luck for the bride and the bridegroom, and everyone stopped to buy something from them, because it's bad luck to refuse them on the day of your wedding. Everyone wanted some kind of tip on that day. The man who married us waited at the top of the stairs and hurried us along, he took us to a special room and told us what to do, when to stand, when to sit, and what to say, as though we were marrying him, and not each other. He had thick eyebrows and glasses that rested so low on his nose, that they fell off as he was reading the vows, he caught them in his hand, and carried on as though nothing had happened, because he knew all the words off by heart.

Marina had made her own wedding dress, it was a big white dress that rustled even when she wasn't moving. She looked like a little princess. She had made a smaller version of exactly the same dress for the doll that was called Claudia, and Claudia wore it long after we had returned from our honeymoon, and long after it was appropriate, like a Christmas carol in the summertime.

After the man had read the vows, we were taken to a desk where we had to sign lots of papers. He made us stop with the pen poised over each document so that people could take pictures as we were signing them, even though hardly anyone had a camera, and the ones who did take photographs took them out of pity because we were made to stand still. The smiles on our faces melted away as we waited to hear the click of the camera before moving on to sign the next form. I never even saw a single one of those pictures afterwards. But we were not formally married until the man who controlled the whole thing had stamped all the papers with the official stamp which was more important than anything that day,

more important than the ring, or the bride or the groom. He sat down at the chair, opened up the drawer in the desk, took out an inkpad and a stamp which he placed on the table, he pressed the stamp against the inkpad and then held it over the first document as though he was waiting for someone to take a picture of him as well. He stamped the paper so hard, that he lifted himself slightly off his chair to do it, but in the end it came out smudged, and you could barely read the date in the centre of the circle that he stamped on the marriage certificate. He blew the certificate dry, put all the papers together and tapped them on the table to straighten them out, like the newsreaders do on the television once they've finished telling you all the bad news. 'You are now man and wife.' He looked at us over the top of his glasses.

I kissed Marina on the mouth. The man took off his glasses put them on the table in front of him, stood up from the chair and started clapping his hands high up in the air so that everybody else would join in. At that moment we really were man and wife, and all the guests crowded around us to kiss Marina and to shake my hand. Mr Bordan was the first, he took both my hands in his own, and the newly placed ring on my finger felt uncomfortable as he squeezed my fingers tight with his own enormous paws.

We drank and we ate at a bar near the town hall, the bar was too small for all the guests and everybody was stuffed inside, like on the trains in the morning. There were even three musicians who played their instruments as they moved among the guests, one with a fiddle, one with an accordion and one with a tambourine, how they managed to move around and play any music at all was a miracle. The man with the tambourine had teeth that were made of gold and he held his instrument high up in the air as he moved through the crowd of people, and the one who played the fiddle almost poked people's eyes out with his stick. I also moved through the crowd, most of them unknown to me, looking for Marina, but I couldn't see her anywhere.

For our wedding present Mr Bordan gave us a cutlery set that they made in the steel factory where he worked, he said

that he had made it with his own hands, but Thomas was standing just behind him and made a face to indicate that what his father said wasn't true. The cutlery set was the best one they made, it came in a special box that was covered in leather on the outside and white satin on the inside, just like the white satin of Marina's wedding dress.

'He didn't make those with his hands.' Thomas spoke as soon as his father had moved away, he tipped his glass of wine so far in one direction without even realising, and I thought it was going to spill onto the floor. 'That's what you have to remember Daniel Glick.' He pointed at me with his finger, and again I watched his wine glass as I waited for him to finish his sentence, but he was so busy trying to stand up straight that he had forgotten what it was that I had to remember.

'What do I have to remember?' I took a sip from my own glass.

'Oh yeah,' he said, 'that you have just married yourself into a family of liars.'

'That's not true,' I said.

'Are you calling me a liar?' Thomas laughed out loud and you could see that his teeth and his tongue had soaked up all the red of the wine.

'Marina isn't a liar,' I said to him.

'What?' he almost choked on the wine that he had just sipped, 'she's the worst of all of us, she tells more lies than the devil himself.'

'Well she doesn't lie to me.'

'I bet she does,' he put his hand out so that I would bet with him, 'I bet you a tenner.'

'All right,' I said and shook his hand.

'I bet she hasn't told you that we're being thrown out of our apartment for instance.'

'Now you are lying,' I said to him.

'All the buildings in our street are being demolished to make way for a new parliament building. We've been given a flat in the outskirts, and she won't have a room to herself any more,' he tried to pull me towards him but he couldn't even reach me. 'So it's a very lucky thing that you have a place all to

yourself,' he winked at me, 'isn't it? And that you came along when you did.'

'When were you told about the flat?' I asked him.

'Long before she met you.' He poked me in the chest.

'She must have forgotten.'

'You are joking, she's been bawling her eyes out about it ever since she found out, she needs a whole flat just for her stupid dolls,' he said, 'and you owe me a tenner brother-in-law,' he held his hand out for the money.

Suddenly one of Mr Bordan's enormous hands struck Thomas on the side of his head, and the smile on his face vanished in a moment, as though he had sobered up in that very instant. He brought his hand up to his face to protect himself from any more blows, and this time he did spill the wine in the glass, onto the floor and onto his jacket, but Mr Bordan didn't strike him again, one strike from his enormous hands was enough. He looked at Thomas and then started to move amongst the other guests. When Thomas took his hand away, the side of his face was bright red, and his ear was almost purple, and although his face went back to its normal colour, his ear remained a shade of purple for the rest of the evening. I took a tenner out from my pocket and gave it to him.

Marina had been in the toilet the whole time, and she had missed out on most of the party, her mother was keeping watch outside and wouldn't let anybody in, she directed the men to an alleyway by the side of the road and to the women she just shrugged her shoulders and asked them to be patient because her daughter wasn't ready to come out yet.

'Is she all right?' I asked her.

'She's doesn't want anyone to see her crying on the day of her wedding,' said Mrs Bordan.

'Is it something I've done?'

'It's nothing to do with you,' she said as though I was a complete stranger. She turned away another one of the male guests and pointed him towards the alleyway.

'Please Mrs Bordan, let me talk to her,' I said.

'There's not a thing you can say that will make her feel better.'

A man with a moustache who was standing next to me, and who I had never seen before, put his hand on my arm. 'It's nothing to do with you,' he said in a deep voice that smelt of cigarettes, again like I had just walked in off the street.

'She's my wife,' I told him.

'Your what?' He asked.

Mrs Bordan introduced me as the groom. 'Oh yes, I saw that,' he said, 'I thought you looked familiar. Congratulations.' We shook hands.

'Hold this, Daniel.' Mrs Bordan gave me the glass of wine that she was holding, 'I'll go and ask her if she wants to see you, but make sure no one else comes in, this lot would throw a crying bride out in the street just for a quick piss,' she said, before going inside.

'Well it is a toilet,' said her brother as soon as she had gone in. 'You'll have to get used to that one,' he pointed with his chin to the toilet door, 'she's just the same as her mother,' and then he left.

Mrs Bordan came out from the toilet and told me that I could go in just for a moment. I gave her back the glass of wine and pushed the door open.

Marina was sitting on the toilet, there was hardly enough room for me, and her, and that big white wedding dress, she had her head in her hands and was sobbing uncontrollably.

'What happened?' I asked her.

She raised her head, her face was red and her eyes were puffy from so much crying. 'Look at this dress,' she said.

'What's wrong with it?'

'It's ruined, that's what's wrong with it.' She lifted up her dress with the tips of her fingers as though she was picking up an old damp rag, the bottom of the dress was grey with the dirt that it had swept up throughout the day, and that's why Marina was crying.

'But that's a sign of good luck on your wedding day.'

'No it's not, it's fucking horrible, I look like a tramp,' she lashed out at me like I was responsible for it.

'Don't worry about the dress Marina.' I put my arm on her shoulder, but Marina was inconsolable, she reached for a roll

of toilet paper that was on the floor handed it to me and I broke a piece off for her, she blew her nose into it and then tossed it onto the floor, which was already littered with so many of them.

'And look at this.' She stood up at once, pushing me to the side, twisted the dress all the way around and pointed out a wine stain that was on the back of the dress, and I wondered how she had ever seen it in the first place.

'I'll tell you one thing,' she said, still sobbing, 'I'll never wear this dress again.' She sat back down on the toilet and put her head in her hands.

We moved into my grandfather's old flat, which is a ten-minute walk from the train station. It's a thirties' building with a metal door that scrapes against the concrete when you open it. It has narrow creaking stairs, wooden floors, and the lift hasn't been used since the earthquake, because everyone is afraid to get in it, the old women who clean the stairs use it to keep their buckets and their brooms. This was the place where I had lived almost all of my life.

My flat has two rooms and a kitchen, we shared the bathroom with the other people on the same floor, usually it was busy, and usually you didn't even want to leave your flat, so you just washed yourself over the kitchen sink. Marina had two flannels that she hung from a line over the sink, one of them was to wash between her legs and the other one was for everywhere else, she used them almost every morning, and by the evening they would be dry and hard, like old pieces of bread. Sometimes I couldn't wait to get in the toilet and I pissed straight into the kitchen sink, my grandfather used to say that you hadn't really been in a house until you had pissed in the sink, but after Marina came to live there I didn't do it any more.

Marina recreated the bedroom in her father's house almost exactly; all her well-dressed dolls were placed on the bed, huddled together against the pillow, a little fearful of their new surroundings, staring at the door, terrified of what might come through it, at night she would sit them all on the floor,

29

and they stayed awake even when we went to sleep. She had so many little things that she spread all over the flat, she had a box just like the box of cutlery that her father gave us for our wedding, she kept it in a drawer under some clothes. Inside there were photographs, her birth certificate, all her foreign coins, her necklaces and her beautiful hairpins, which she couldn't wear because her hair was too short. She also had three watches which she kept there, they all worked, but only one of them had a strap, she didn't wear it because it was a man's watch and her wrists were too thin. Everything in the box had its own story like they were displays in a museum, she told me those stories over and over, and still I asked her to repeat them.

And all the things which she had brought into that house, she had slowly taken out again, one by one, until the flat was so empty that you could hear your own echo inside. There were no dolls on the bed, no clothes in the drawers, no pictures on the wall, and no soap in the kitchen. She had cleared the whole place of all her belongings because I couldn't give her what she wanted.

After our wedding, Marina and I took the train to the seaside and stayed there for a week. We took our places in the compartment on the train, and put our suitcase on the luggage rack above our heads. The holiday season had ended, and the trains going to the coast were not as busy as they had been during the summer, so we guessed that we would have a compartment to ourselves. We were wrong. The door slid open and an old blind woman with a face full of wrinkles was led by a conductor to the seat directly opposite me, she was wearing a long black coat and a black headscarf, one of her eyes was completely closed and the other was fogged over, both eyes wept, and she had a little white handkerchief with which she wiped them.

The train was late leaving the station. The hawkers and the vendors walked up and down the corridors of the carriage selling drinks and cakes and postcards, the deaf and dumb

people sold pens and pencils and the puzzle books that Marina loved so much, they opened and closed the sliding door of our compartment, and each time they did, the smoky air from the corridor outside replaced the clean air of the compartment inside. Eventually the blind woman sitting opposite became tired of these interruptions and said to the young boy who was selling little photograph albums, 'Don't you see that I am an old woman and want for nothing but my sight?'

He looked towards us but we said nothing, and he left without even closing the door to the compartment, the old woman muttered to herself that it should always be closed, and she tried to close it by herself but it got stuck halfway, Marina nudged me with her elbow and I took a hold of the handle and pulled it towards me, the old woman thought that she had closed it all by herself so she didn't bother thanking me, she didn't even know that there was anyone else in the compartment, we were that quiet. So Marina and I remained silent so that the old woman wouldn't know that we were also in there, just in case it frightened her. Marina quietly opened up her puzzle book and drew long circles around letters which made up words, and I looked out of the window and saw children waving at the passengers on the train, and the dogs barking, and then the fields, the hills, the mountains, and finally, the sea.

Slowly the train rocked the old blind woman to sleep and she began to snore over the sound of the engine, and only then did Marina and I dare speak to each other. She whispered, 'I love you,' for the very first time, and I whispered it back for the umpteenth time. Then she put down her puzzle book and her pen, I took her hand, put it in mine and did not let go until we saw the sun glimmering on the surface of the water as we reached our destination.

Our hotel was on the seafront but our room overlooked the back. It was famous for couples just wed. There were flowers in our room when we got there, and when we came back each afternoon the bed was made and everything was in its place again. In the day, we walked along the whole length of the beach, Marina looked for shells and pebbles, and she brought

back to the hotel as many as she could carry in her little hands, but I never thought in a million years that she would keep them and take them home. For months afterwards she often picked them up and wiped the dust off with her fingers, and held them up to her ear, and still the ocean played inside. At night we ate at the places along the seafront where you could still hear the gentle coming and going of the water, and we watched the lights of the fishing boats out on the horizon, Marina said that they looked like floating stars, and so they did.

Two

The day after Marina left, Mr Ferrer called me into his office first thing, I didn't even get a chance to take my coat off and hang it on the row of hooks by the door. He pulled sharply at the curtains as he closed them behind me, the rings scraped against the metal rod, dust from the material floated in his office and didn't fully settle until he had finished what it was he had to say.

'Sit yourself down Daniel.' Mr Ferrer smiled, put his hand on my shoulder and guided me towards the chair that he had squeezed into his small office, and straightaway I felt that pang in my stomach that you get when you know you're in trouble. 'I'm sorry to say that I don't think your mind has been fully on your work lately,' he paused, 'and I'm not the only one to notice.' His hand strayed away from his lap where it had been resting, and it moved in the direction of the people on the other side of the curtain, who were suddenly so quiet that I could even hear someone sharpen a pencil, I swear to you I could actually hear the blade of the sharpener cut through the wood as the pencil turned, that's how hushed they all were. 'Your colleagues are as worried about you as I am.' Mr Ferrer's hand cast a shadow against the wall that could have looked like a dog or could have looked like a rabbit, but really it just looked like his hand. 'Daniel are you listening to me?'

'I am listening.'

'We're all of us very worried about you Daniel because your work is not up to the standard which we would expect from any of the staff here, and I'm wondering if perhaps this job is a little too much for you.' He put his hand back down on his lap, the shadow disappeared from the wall, and the fingers from one hand locked into the fingers from the other. 'So we've decided that as of today you will be working in the postroom with Mr Grisold.'

'In the postroom?' I said.

I had only ever been allowed down to the postroom during my first week, when I was given a tour of the whole building and introduced to the people who worked there, I forgot their names as soon as I had been told them, but I did remember that the postroom was in the basement, and that it had no windows, and that there was no air, and no light, and that no one ever went down there.

'You'll help him open the post, and assist him with all his other duties.'

'I promise you I'll put more effort into my work from now on.' My voice had started shaking as if I was about to cry, and it barely sounded like my own voice any more, 'Please Mr Ferrer you have to give me a second chance.' Mr Ferrer looked at me in disbelief, and I tried so hard to make it sound like my own voice again although I knew that it wouldn't make any difference to him one way or the other.

'We've got a new desk for you down there,' he said. 'That's where I started working you know, and look at me now.' Mr Ferrer was only being nice because he could see how distraught I was at the idea.

'Please,' I said to him, I put my hands together as though in prayer, and I would have got on my knees and begged but there was no room in his tiny little office.

'Mr Grisold is looking forward to working with you Daniel, he's heard so much about you.' He stood up from his chair, and that was the end of our little chat, he held out his hand so that I would shake it, and have this little chat over with. Again his hand cast a shadow against the wall and this time the shadow really did look like the head of a dog with its ears pointing upwards and its mouth open ready to bite.

'Daniel.' Mr Ferrer saw that I was looking at the shadow on the wall, he put all his fingers together so that the dog's mouth closed and his ears flattened and it looked like the shadow of a hand again, but he held it so unnaturally that I couldn't grip on it when I shook it. And just like that my job of three years had come to an end without so much as a warning, and I was reduced to opening the post in the basement with old Mr Grisold.

I pulled the curtain open, more dust passed from the old material into the air, and the buzz of activity started again in the office as though it had been going on all the time.

The new wooden desk that Mr Ferrer had talked about wasn't new at all, it had dates in roman numerals carved into the wood, and the names of people who must have worked there long before my time because I hadn't heard of any of them, and chewing gum stuck to the underside that had been there so long that it was as hard as the wood itself. It was much smaller than a normal desk, it was more like a child's desk taken from a school, with a chair of the same size to go with it, I could just about squeeze my legs underneath it when I sat down, and then I could hardly move. Another lie from his evil mouth I thought to myself. I took my pen from the pile of things that were on the floor next to the desk, and I began to write my own name on the desk, and that's when old Mr Grisold walked into the room.

'Bastards,' he said to himself before he had even seen me. He tossed some of the letters that he had been collecting from all the departments onto a table on the other side of the room. He opened one of the letters in the pile and began to read it, then he screwed it up into a ball and tossed it in the bin. 'What crap,' he said. Suddenly he noticed that there was someone else in the room and he turned towards me. 'Who the hell are you?'

'My name is Daniel Glick,' I said, 'I'm the one who's going to be working down here with you.' I pushed against the desk to release my legs from underneath it.

'Who the fuck told you that?' he said, stepping towards me, hands on hips.

'Mr Ferrer,' I told him.

'Daniel Ferrer is a stupid bastard,' he said, and stepped back again.

'He said you knew all about it.'

'I wondered what that stupid desk was doing here.' He pointed at the desk that I was sitting at. 'I suppose that's all your stuff there on the floor.'

I nodded my head.

'Well you won't be needing the half of it, all you need to work in here is a pair of eyes and pair of hands,' he said, 'and a letter opener.'

'I don't have a letter opener.'

'It's the same thing as a knife, go and get yourself one from the canteen, if they haven't stolen all of them, and keep it somewhere safe otherwise it'll vanish, they'd steal the fucking windows in this place if they could get them in their bags,' he said, 'anyway that's a stupid desk for a person. I thought I was going to be working with a midget.' Mr Grisold began to laugh and his laugh turned into a cough.

'Mr Ferrer told me that I was going to get a new desk.'

Mr Grisold looked up at me, the smile had vanished and the coughing had stopped. 'I hate Daniel Ferrer, I wish it was him who had died in the earthquake and not that other poor bastard,' he said, 'there's no justice in this world.'

And I must admit that I had thought the exact same thing many times, but I would never have said so out loud, certainly not in front of someone at work.

Mr Grisold had a thick moustache that was grey from age and yellow from smoking, every day he wore the same faded blue overcoat that came down to his knees; it had a small badge on the pocket with the emblem of the national postal system, but I didn't have to wear one of those awful overcoats, thank God. He knew everybody in the building, and everybody knew Mr Grisold because he had been there all his life, and because he was the one who collected and delivered the post from all the different departments. If the use of a stamp was not authorised he would arrange to send the letter if he was given a cigarette, everyone knew that unofficially, what I hadn't realised was that he smoked all those cigarettes all day long in that little room with no windows and no light and no air, sometimes he lit one cigarette with the smouldering butt of another, and when he was finished he tossed it to the floor with all the other rubbish, and I don't know how he didn't burn the whole place down. He laid out all the cigarettes that he was given, counted them and put them into different piles

for the different brands, and some brands he would only smoke at work and some he would only smoke at home, and some only on a Sunday, and that's what he did for most of the day. No wonder he needed help in the postroom, I thought to myself.

I also hadn't realised that he complained all day long about everybody and everything. He hated all the managers but most of all he hated Daniel Ferrer, I think he hated him even more than I did. We swapped stories about how awful he was and how much we hated him all day long, and that's about the only thing we had in common. He told me that Mr Ferrer had helped him with the post for awhile and that he was the laziest person he had ever worked with, he told me that he would go round the whole building scratching his name on all the little corners of the warehouse. 'The way that dogs piss on trees,' he said. 'And do you think that he has all the girlfriends he says he does, with a face like his?' He laughed. 'He looks like a crumpled up old rag.' Even I laughed at that. 'He has to pay for sex, he goes to the bar of the Grand Hotel, picks up a whore and pays her to have sex with him, I'd swear to that on my own mother's grave, God rest her soul,' he crossed himself. 'That's where all his money goes, that's why he can't even afford a decent shirt. Imagine having to have sex with that dirty bastard.' He made a face and then I made a face and we both laughed.

My job was to open all the post that we received, put the date on it with a special stamp that I was given, and then separate the letters into different piles for all the different departments, just like Mr Grisold did with the different brands of cigarettes for the different days of the week. I also had to fold things and put them in envelopes. I got paper cuts on my hands again and again in exactly the same places because I was doing the same thing all the time. Mr Grisold showed me how to fold them in special ways so that they would fit perfectly into the envelopes; his hands were dry and hard like the skin of an old lizard, and I doubt he got cuts on them in the same way I did. Sometimes the stamps on the incoming post were not franked and they could be used again,

Mr Grisold said that I had to tear them off and give them to him because they were the stamps he used when people couldn't get them authorised, and that's how he earned his cigarettes, he told me that it was years since he'd bought a packet from a shop. Mr Grisold would then take the letters to all the different departments, and that was just about the only real work he did.

I had lived in the same place all of my life. Of all the neighbours I knew Mr and Mrs Roman the best and I spent as much time in their flat as I did in my own. Mrs Roman used to make all of my clothes on her sewing machine, she used to cut my hair, take me to the circus, give me presents, and fill my pockets up with biscuits before going home. My grandfather said that they gave me things because they wanted me to look after them when they got old. They used to beg him to let me stay the night with them in their apartment, and he would refuse until they started putting money on the table and finally he would succumb. I'd pack my pyjamas and climb the stairs to their apartment and he would take the money to the bar across the road and drink himself into contentment. They even gave me a puppy as a present to cheer me up after my parents had left, but my grandfather was as jealous of that dog as though it was a rival in love, and he found some excuse to put it in a sack and throw it into the river from the bridge by the factories where the currents are so strong, that they disappear under the water faster than the eye can see. That's the place where everyone goes to get rid of the things that they don't want any more, and where people go to throw themselves into the river. They sink right down to the bottom and become embedded in the mud, and that's where they remain even though the current is going so fast. They say that if you drain the river you will find all these upright bodies on either side of the bridge, like the statues of the gardens in the former royal palace. That's what they say.

Mr and Mrs Roman's place was always tidier and cleaner than ours, the lights in their flat shone brighter, and they had things that we didn't have. They had this cabinet against the

wall with light bulbs in it, and when you switched it on the whole thing would light up just like the Cathedral or the Opera House at night time, and you could see all the ceramic figurines and all the little ornaments that Mrs Roman cherished more than anything else in the world. The floors in their flat were polished every week. They were so shiny that they almost looked wet, you had to leave your shoes in a row by the door and wear slippers instead so that you wouldn't scratch the wooden floors. I always felt a little sad every time I put my shoes back on my feet and walked down the two flights of stairs to my own home.

Mr Roman and my grandfather had been best friends almost all their lives, although at times if you had seen them together you would have thought that they were the worst of enemies. Mr Roman had such a bad stutter and took so long to say anything, that everybody around him finished off his sentences for him. My grandfather finished his sentences in a way that made him look like a fool, he'd say the exact opposite of whatever Mr Roman had intended to say, and Mr Roman's face would go bright red and he'd try to speak but he got more saliva out than words.

Then Mr Roman got sick, every time he coughed he sprayed blood all over the place, on the walls and the floor and everywhere. His wife would get up from her chair and clean up the blood as if it was the most natural thing in the world, and my grandfather would continue talking as if nothing had happened, and we all knew that he didn't have that long to live. The doctor had given him tablets for the pain, but Mr Roman couldn't swallow the tablets, in the same way that he couldn't get his words out when he wanted to, and his wife had to crush them up in his food, as if he was a dog.

In the weeks before Mr Roman died, my grandfather didn't sleep a single night. He always complained about not sleeping, but I knew when he was lying because I could hear him snoring from the living room where I slept. But the house was so quiet at that time, that it seemed as if it was my grandfather who was dying and not Mr Roman.

They buried him on a Thursday. I was seventeen and I

had never been to a funeral before. My grandfather and Mrs Roman linked arms the whole day, he had to hold her up because she couldn't walk in a straight line or stay standing for too long, as though she had a new pair of shoes that rubbed against her feet. Afterwards we all went back to her flat and there was a long row of shoes by the door that almost reached to the end of the corridor, Mrs Roman said that they could keep their shoes on that day, but everyone took them off out of respect.

Mrs Roman had looked after her husband until the very last day, and then she didn't want to do anything or see anyone, she stopped making my clothes and we stopped going to the circus and she even stopped polishing the floors. She became more and more forgetful until she seemed hardly to know me any more, she hardly knew anyone any more. You could see in her face that something wasn't right, she talked about her husband as though he was still alive and always asked me about how my dog was, even though it was years since my grandfather had thrown it into the river, and then some days she was the same way that she had always been and you wouldn't have known the difference.

After we were married, Marina and I bought Mrs Roman's old sewing machine from her, and on the day we went to collect it Mrs Roman seemed fine. She sat us down on the sofa and brought us coffee and little cakes that were all different colours, there were yellow ones and pink ones and white ones, but they all tasted exactly the same.

'You're the ones doing me a favour by taking it away,' she said, 'I can't even sew a button on with these fingers.' Mrs Roman held up her fingers so that we could both see how crooked they were.

'I can do any alterations for you.' Marina took another little cake from the plate on the table in front of us, she only took the little pink ones at the bottom of the pile even though there was no difference in taste.

'For what?' She held out both her hands. 'I hardly even get up from this sofa any more.'

'You must get out more, even if you just walk up and down the stairs for exercise,' I said.

'I can do them for you for free if you like.' Marina spoke as she chewed through the little pink cake and you could hardly understand her.

'Mrs Roman used to mend and alter all my clothes on that machine,' I said.

'Not just Daniel's clothes, my husband's clothes, my own, anyone who'd ask me, in fact,' said Mrs Roman.

'I'll take good care of the sewing machine.' Marina swept the little pink crumbs from her skirt onto the floor.

'But now Daniel has such a pretty young wife to look after him and my husband has gone, and I've no use for it.' Mrs Roman took my hand in her own and squeezed it very tightly.

'I wish you were selling the cabinet as well.' Marina looked straight in front of her at the cabinet.

'My husband's health meant more to me than anything else in the world,' said Mrs Roman.

'Marina loves the cabinet,' I said.

'I just love it when it lights up,' said Marina who was suddenly mesmerised by it.

'I'm not sure she wants to sell it though,' I said.

'My husband's health meant more to me than anything else in the world,' Mrs Roman was also mesmerised, she hadn't even heard a thing we'd said, she was nodding to herself as though she was answering all kinds of other questions in her head. She said the same thing about her husband and I knew then that we'd lost her. I picked up the cup with my hand, the one that Mrs Roman didn't have in a fierce grip, and tilted my head all the way back so that the last drop would slide into my mouth, just for something to do.

'I'd love it if you could turn the lights on in the cabinet for me,' said Marina who was still mesmerised by the cabinet whilst Mrs Roman was mesmerised by her own memories.

'She can't hear you,' I whispered, 'I think she's gone into a trance or something, do you think we should call the doctor?'

'She'll be all right.' Marina stood up from the sofa staring at the cabinet in front of her, she moved closer to it and switched on the lights inside it so that the whole cabinet lit up. She looked at all the ornaments inside the shelves, and she touched them with her hands and she picked them up and studied them, and I kept looking at Mrs Roman hoping that she was still deep in her trance, because in all the time that I had known her I would never have dared to do what Marina was doing.

'What are you doing?' I asked Marina.

'I'd do anything to have a cabinet just like this one.' She got right up against the cabinet so that I couldn't see what she was up to, but I saw her take something, I swear I saw her take one of the little ornaments from the cabinet and put it up her sleeve, she switched off the lights and turned briskly to Mrs Roman. 'Thank you for the coffee, and the cakes, it's been lovely, we'll have to do it again sometime,' she said, even though she knew that Mrs Roman couldn't hear her, and all the time you could see this obvious lump in her sleeve where she had concealed whatever it was that she had stolen.

'What are you doing?' I asked her.

'I need to get back now, but Daniel why don't you stay and finish your coffee and bring the sewing machine down later,' she said, knowing full well that my cup was so empty that it looked like there had never been any coffee in it at all. In any case Mrs Roman was still gripping my hand tightly and I couldn't have got away even if there was another earthquake at that moment, and you would never think that her fingers were as useless and as crooked as she had said.

'I have to go now too,' I said after Marina had left.

Mrs Roman did nothing, she just looked out in front of her, and I had to bend her fingers back so that she would let go, they really were crooked just as she had said, and that made it even harder to get them apart.

The sewing machine was in two parts and when I returned for the second part, Mrs Roman was still sitting in the same place staring out in front of her as if she had seen a mouse, I called her name but she didn't answer.

'Are you all right Mrs Roman?'

'I'm just fine Daniel, how are you?' She spoke slowly and carefully as though she had just learnt the language.

'I'm taking the rest of the sewing machine now.'

I took two more little cakes and put them in my pocket, but I didn't think that was as bad as what Marina had done, because Mrs Roman would probably have given them to me anyway, although I doubt she would ever have given Marina the ornament she had stolen. Only the yellow and white cakes were left because Marina had finished all the pink ones, but they all tasted exactly the same.

A week after Marina left, there was a knock at the door and for a moment I thought she'd come back. I was sitting in the armchair watching the man on the television read the news, which was so bad that I had stopped listening to what he was saying. I tried to get up, but the armchair was old and had sunk so low that I struggled to raise myself from it, just as my grandfather had struggled to raise himself from it so many times. I turned down the volume on the television so that you could still see the man but you couldn't hear all the bad news that he was spouting.

'Who is it?' I moved over to the door and put my hand on the lock, ready to open it.

'Open up,' said a man from the other side of the door.

'Who is that?' I asked again.

'It's the police,' he said.

I opened the door just enough to see the man who was standing there. He looked older than he sounded, he was wearing a sheepskin jacket and a pair of glasses, and he had a beard that was so thick that you could hardly see the skin on his face, he had little drops of rain all over him, in his beard, on the lenses of his glasses and on his coat.

'What's your name?' he asked me.

'My name is Daniel Glick, what's yours?'

The man unbuttoned a big brown button on his coat in the shape of an elephant's tusk, and reached into his pocket for a card that he held so close to my face that I could smell old

cigarettes on his fingers. On the card was a photograph of a man with glasses and a beard who must have been him, but could really have been any man with glasses and a beard that was out of control, and still I didn't know what he had come for.

'We've had a few complaints,' he said. 'May I come in?' The man pushed the door open, and I stepped back to let him into the flat. Following behind him was another man who I didn't even know was there. He was much younger and had a bright red face, as if he had just stepped out of a hot bath, his hair was so thin that you could see right through it, you could actually see where the raindrops had fallen and where they rested on the hairs in the middle of his head. He closed the door so quietly behind him that I didn't even hear the latch. 'Is your wife's name Marina?' asked the first man.

I nodded my head suspiciously wondering what it was that they could want.

'Is she in tonight?'

'What do you want to know for?' I said.

'We just want to clear up some rumours that have been circulating in the neighbourhood, that's all.'

'She won't be back for a few days.'

'For a few days?' Both men looked at each other for a moment, the younger one was patting the hair on his head gently with his hand to take away the drops of rain that were sitting there, he then looked at the palm of his hand to see how much of the rain he had collected, and all the time he didn't say anything, he just wiped the moisture from his hands and looked around the room as though he was a prospective tenant, and it was the other one who did all the talking.

'Where has she gone?'

I shrugged my shoulders.

'You don't even know where she's gone.' He tutted away to himself sarcastically, 'Your own wife,' he said. 'Did you know that your neighbours have been putting money on you doing away with her?'

'I would never hurt a fly,' I said.

The other man started to wander around the flat, he went into the living room, looked around, and switched off the

television. The one with the beard who did all the talking asked for a glass of water and I took a cup and filled it with water from the tap, and he took a sip and made a face as though the water was bad and tipped the rest back into the sink.

'What's he doing?' I asked.

'He's just making sure there are no dead people here, that's all.'

He opened all the drawers and the wardrobe in the bedroom, and I heard the empty coat hangers clink against one another. When he came back into the room, he whispered something right into the other man's ear that I couldn't hear, and then he gently patted his head again and looked at the palm of his hand like he had done before.

'Doesn't look like your wife is ever coming back,' said the older one with the beard who did all the talking.

'I would never do anything to hurt her,' I said, but neither of them would believe me. The younger man with the red face who had still not spoken, put his arm around me like he was an old friend, and all three of us left the flat without even turning the lights off or closing the door behind us.

I had been to the central police station many times before, it was the place you went to register missing relatives after the earthquake. It looked quite grand from the outside, but once inside the rooms were small and partitioned and the further into the building you went the smaller the rooms became. I went there every day after the earthquake for news about my grandfather. On the first day there were so many people waiting to do the same thing that it was impossible even to get near the door, they made us wait in the dusty little park in front of the building. I waited for hours to speak to someone, and when I finally reached the front of the queue, they told me that my grandfather's name didn't appear on any of the lists, so I had to go back the next day and do the same thing all over again. Every day there were fewer and fewer people waiting as they found more bodies in the rubble, but they never found my grandfather, and after awhile I stopped going to the police station altogether because the man who I

spoke to there, who knew me by my first name, told me there was no point in coming any more.

The man with the red face pulled at the door of the police station and held it open as if I was their special guest, the other man gestured with his hand so I went in first and they followed behind me. There was hardly anyone in the waiting area that day, just a young man with a dirty face asleep on one of the green plastic chairs that were lined up against the wall. He was leaning so far to one side that he should have toppled over all the way, but he didn't, he opened one eye when he heard us walk in, straightened himself up and closed his eye again. There was a woman sitting behind a grey metallic desk with a phone on it, her face was thin but her body seemed large, and she was pressed right up against the desk so that both her breasts rested on top of it, like two sleeping kittens. She wore a big black dress with red flowers on it, and she too looked like she was on the verge of sleep, but when she saw us she rose so suddenly from her chair that the chair crashed on to the floor behind her, and the man with the dirty face opened both of his eyes, and all three of us stopped right in front of her desk.

'I can't believe it.' She put her hand over her mouth, like she had just seen a mouse or a spider or a rat.

'What's got into you?' said the man with the beard. 'What can't you believe?'

'You've found him.' She still had her hand over her mouth, so you couldn't see her lips move, and you could hardly make out her words, but you could see that her eyes were staring into mine and that she must have mistaken me for somebody else.

'You know this one?' The man with the beard tugged at the sleeve of my jacket. She took her hand away from her mouth and began to shake her head from side to side without saying a word.

'My name is Daniel Glick,' I said to her.

'Are you sure you've not made a mistake?' said the man with the beard.

'Of course she's made a mistake, I've never seen her before,' I said.

The woman looked me up and down, and put her hand up to her mouth again, 'You look so much like him.' She picked up the chair that had fallen behind her. 'I'm sorry,' she said and sat down again.

The man with the beard tutted, and the other one took a deep exasperated breath, in and out through his nose, and all three of us carried on walking further into the building through a pair of swinging doors that crashed against one another behind us as they swung backwards and then forwards again. They kept on crashing every time they met, until finally they were still.

'What was that about?' said the man with the beard. 'Stupid woman, and then they want to be officers just like the men.'

The other one made a laughing sound through his nose, that sounded like the engine of a car when it won't start. 'You've found him,' he said in a high-pitched voice that mimicked the woman, it was the first time I had heard him say anything at all.

'She made a mistake,' I said, and he made that laughing sound through his nose again.

'Yes, all right we believe you,' said the man with the beard.

'That's about the only thing we do believe,' said the other one, still mimicking the woman's voice.

We came to a small room that had nothing in it except a table and some plastic chairs, like the ones in the waiting area, no window, nothing on the walls, just a very high ceiling. The tube of lighting that dangled from two cables above our heads, flickered for a moment before going on, making a slight buzzing sound that didn't stop the whole time we were in there, as though there was a fly moving constantly through the air above our heads. They asked me to sit on one of the chairs at the far end of the table, and that's where I sat.

The two men had to put some of the chairs outside to make room for themselves, but the metallic legs of the chairs had become entangled in one another, and it took them a long time to pull them apart, the man with the red face broke out in a sweat, and his face reddened further still as he tried to pull one chair away from another, as if he was trying to

separate two dogs fighting. In the end he lost his temper and pulled them so hard that the metal of one of the chairs bent slightly, and only then did they come apart.

'Can you move your chair a little further back for me?' said the other one.

But there really wasn't much room for me to move the chair at all, and they pushed the table right up against me so that I was almost pinned against the wall. All three of us shifted in our seats, the man with the red face patted his forehead with the palm of his hand to take the sweat away, then he looked at his hand to check just how much he had exerted himself by pulling the chairs apart.

'Do you want to tell us what you did with her or shall we tear up all the floorboards in your flat till we find her?' asked the one with the beard.

'I told you I'd never do anything to hurt her,' I said.

He took out a cigarette and a lighter from the pocket inside his sheepskin jacket, and he lit the cigarette.

'Well your neighbours are saying that she's either under the floorboards or in the pipes or in a bag under the bed.'

'No,' I said.

'They're putting money on it,' he said, 'they heard you two argue, and then the next thing they know, she's gone, no one knows where.' Some of the smoke from the cigarette came back out of his mouth as he spoke. 'What would you think Daniel Glick?'

'But I would never harm Marina,' I said.

'Well that's not what your neighbours think, and it's not what I think either.' The man with the red face spoke again in that same high-pitched voice that was more like a woman's voice than a man's, and it turned out that was how he spoke all the time, he hadn't really been mimicking the woman in reception at all, maybe that was why he had said so little. 'They don't seem to have a very high opinion of you at all.'

'They hear arguments, then they hear screams and then the next thing is she isn't there any more. Wouldn't you think the same thing?' said the one with the beard, and he made a face

that was almost a smile, and his teeth were yellow and stained from the cigarettes like his beard and his mouth and his fingers, 'Wouldn't you call the police as well?'

'They all know I would never harm anyone.'

'So where is she then?' asked the one with the high-pitched voice, folding his arms so that you could hear his leather jacket squeak as one sleeve curled into the other.

'She's gone away for a few days.'

'Who takes all their worldly goods for a few days? Do you think we're stupid?' Slowly he unfolded his arms and you could hear the leather squeak again; his arms moved so slowly, like a snake uncurling from its slumber, and you could just tell that he was about to do something, he put his hands on the edge of the table and pushed it as hard as he could against me so that I could hardly breathe.

'I'd never hurt her for anything, I promise you that,' I said.

'If you can tell us where she is, Daniel, then we can ask her for ourselves whether you'd hurt her or not.'

'I don't know where she is.'

The man with the red face and the high-pitched voice gave the table one last push, then he let go and I could breathe again, he got up from his chair, took off his leather jacket and came over to where I was sitting. 'Stand up,' he said, but there was so little space between the table and the chair that I could hardly get up. 'Stand up,' he yelled at me this time, and his voice was even more high-pitched than it had been before. But there was so little space, and I had to move the chair to the side before I could stand up straight.

'I'm all squashed in here,' I said, but he took hold of my neck, lifted me away from the table and stood me up against the wall.

'I haven't done anything,' I said, but his hand was pressing so hard against my throat that my voice came out high-pitched and squeaky, like the voice of an animal in a cartoon, just like his voice. He looked into my eyes for a moment and his face was so red, and his veins trailed around his neck like rivers on a map, that it looked as though it was me that was clutching at his throat and not the other way around, then

suddenly he bashed my head against the wall behind me so hard that my head made a dent in it.

'I'd never hurt her in a million years.' Again my voice was high-pitched more like a woman's than a man's, and it must have seemed like I was making fun of his voice in the same way that I thought he was making fun of the woman at reception, but as long as he was strangling me there was nothing I could do.

'You're like a broken fucking record,' said the other one.

'She got into a car with another man and I never saw her again, I promise you that's the truth.' He smashed my head against the wall over and over as I pleaded with him in this high-pitched voice that didn't even sound like me, and that just made him angrier.

There was a tap at the door, and both men looked at each other. The one with the beard tried to reach over and open the door, but it was too far away, he tutted because he had to stand up in order to open it. It was the woman from the desk and she whispered things to him so that no one else could hear, he stepped outside with her and closed the door behind him. The man with the high-pitched voice and I were left in the room. He let go of my throat and there was an awkward silence in the room as though we were stuck in an elevator together.

The man with the beard came back into the room, smoking a cigarette that he must have lit whilst he was outside, he took a puff from it and inhaled the smoke so deeply that when he exhaled, none of it came back out, it must have stayed there somewhere inside his lungs.

'Well, they've found the little whore.'

Both me and the other man looked at him, unsure of what he was talking about.

'Your wife, they've found your wife.' He spoke as though it was bad news when really it was good. 'So you can go home if you like, now that you've wasted everyone's time.' He took another puff from his cigarette although the smoke from the last one had not yet come out.

'Thank God,' I said.

As soon as I spoke the man with the red face swung round and hit me in the stomach so hard, that I bent right over, 'That's for all your lies,' he said in his stupid high-pitched voice. He took hold of the hair on the back of my head and he pulled me back so that I was standing up straight again, with the back of his other hand he hit me across the face over and over until I could taste the blood inside my own mouth. The other one pulled him away from me, he took one final puff from his cigarette and put it out inside my ear. I fell onto the chair screaming flicking the hot ash out from my ear, 'I never hurt anyone in all my life,' I screamed. The other one kicked the chair from underneath me, and that's all it took for me to fall down to the ground where he kicked me over and over until I scrambled under the table, away from the reach of his boot. I saw the door open and I watched all four feet leave the room, I heard their footsteps as they got further and further away then faded altogether. Again I heard the buzzing from the tube of lighting that dangled from the ceiling above the table over my head, as if it had just come on again.

From under the table I saw another pair of shoes, different from the ones that had just left the room, women's shoes with heels, and stockings that were almost the colour of skin, creased at the very bottom, they came into the room and stopped just in front of me. A woman's face appeared under the table, upside down.

'What are you doing under there?' It was the woman from reception who had mistaken me for another person. I watched her lips as she mouthed the words upside down and her hair as it almost swept the ground. 'You can go home now if you like.'

'I never hurt anyone in all my life,' I said to her.

'I know you haven't.' A golden chain with a pendant on it came away from inside her dress and swung upside down, like the trapeze in the circus, and it almost swung right into her eye, she pulled the pendant around to the back of her neck to get it out of the way.

'They thought I'd done something terrible.'

'Well they found your wife and she's all right so you can go home now.'

'Where did they find her?' My face felt sore from where they had hit me, I could taste the blood inside my mouth, and my voice sounded different to how it normally sounded, like when you have just been to the dentist and your mouth is all numb, that's how it must have sounded to her.

'It's better you don't ask that,' she said, 'but she's alive and well.' The woman held out her hand under the table and I took hold of it. It was cold but her arm was strong and she pulled me out from underneath. Some of her hair was sticking up in the air, as though she was still upside down, and she put both hands through it and flattened it down again.

'Oh my God.' She shook her head from side to side. 'What have they done to your face?' She raised her hand and went to put it on my face, but my legs were weak and I had to sit on the table so that I wouldn't fall back onto the floor. She put her cool hand to my burning cheek and held it there for a little while, and I liked it, and it felt soothing. 'You're so much like someone I used to know.' She took her hand away from my face and immediately I wanted it back. She pulled at the necklace and swung it from the back to the front. 'This necklace was a present from him.' She dug her nail into the pendant to open it up. 'Don't you think he looks like you?' Inside was a photograph of a man and a woman that was so small, that I couldn't even tell for sure whether the woman was the same woman that was standing right in front of me at that very moment, that's how small it was.

'I suppose so,' I said, not to disappoint her.

'I told you he was just like you.' She closed the pendant up and kissed it before tucking it back into her dress at the front. 'He died in the earthquake.'

'All my family died in the earthquake,' I said automatically.

'They never even found his body.'

'That happened with my grandfather.'

She turned away from me, and led me down the maze of corridors back to the main entrance where she had been sitting. The young man with the dirty face was gone, there was no

one there, she opened the door and held it for me as if I was an unwelcome visitor and she wanted to make sure that I really did go, but then she followed me outside, folded her arms and looked up at the stars.

'It's stopped raining,' she said.

I nodded my head and looked up at the stars, and when I looked down again, she was staring at me.

'You really do look so much like him, it's so weird.' She rubbed her own arms up and down to keep the cold away. 'Not just the way you look but everything about you.' She looked carefully into my eyes, as though she was studying them, as though she was counting every last eyelash that grew there. 'When I saw you, I thought that maybe they'd found him after two years. My name is Gabriela,' she said, holding out her hand to me.

'My name is Daniel Glick.'

The skin on her arms had little bumps all over it, like the skin of a boiled chicken, she took her hand back and folded her arms but the little bumps didn't go away.

'When they brought you in, I really thought it was him.' She moved towards me and kissed me on the forehead. 'Take care of yourself,' she said, and went back inside.

In the park, in the darkness of the park that stretched before me, I saw something move, just a little something that caught my eye, maybe it was nothing, but it was just enough to make me think that there might be someone there watching me, and it was just enough to make me avoid the park altogether, and take the road that circled it as I made my way home that evening.

Three

When I got home, the door was still open, I pushed it further and looked inside. The whole place had been turned upside down, just like after the earthquake, some of the floorboards had been ripped away from the beams underneath and were left tossed in heaps here and there. The rusty crooked nails that had once fixed them to the beams underneath now pointed lifelessly towards the ceiling, like the legs of a dead cockroach.

My things were scattered all over the place, things that had not even been in the same room somehow came to lie next to one another, as though they had been placed there deliberately, and I was so sore all over that I couldn't even bend over to pick things up and put them back where they belonged.

The police had come looking for Marina under the floorboards, in the wardrobe, in the drawers and everywhere they could possibly think of, because they didn't believe a word of what I had told them, and the chaos they'd left behind made me think of the earthquake as though it had just struck.

The earthquake had struck at twenty minutes past eight on a Friday evening, eighteen months before. Mrs Roman had a clock that stopped at exactly that time on the day of the earthquake which she kept as a souvenir. A lot of clocks stopped in the same way, and they wouldn't start up again, however much you wound them. I saw a man selling them in the market a few weeks later, all of them stopped at twenty minutes past eight, he swore that they would only start up again just before the next earthquake, and that they would save your life. There was a small crowd gathered around him and he explained that you had to run out into the street as soon as you heard the tick-tock of the clock, although I don't know if anyone believed him. Mrs Roman said that they were just broken old clocks that he had changed the time on, to twenty minutes past eight, so that you couldn't tell the real

ones from the fake ones, and you wouldn't know until it was too late, until your own house was falling on top of your head. She left her clock on a shelf in the cabinet against the wall, and watched it for hours on end waiting for the ticking to resume, and the ground to start shaking all over again.

They sold a lot of things in the markets after the earthquake, funny little things that you would never imagine. People sold whatever they could, and others bought whatever they had because they'd lost everything. I bought a pair of shoes and a shirt from a man at the left luggage office at the train station, who was selling the things inside the suitcases which remained unclaimed after the earthquake, the shoes were a little big, but they were almost new, and the shirt I could wear to work.

I was at the circus on the day of the earthquake. I had never grown out of it and always went there at least once whenever it was in town. By the time it struck, we had seen all the acts except the flying trapeze, which is always at the very end of the show. We had already seen the family of bears do tricks like they were people and not animals; the mother wore a skirt and the father wore shorts and the little ones misbehaved just like real children, and all of them wore hats on their heads, like the hats children wear to a party. We had seen the dogs jump through hoops, and the bareback riders who stood perfectly balanced on the backs of ponies as they rode round and round the ring. We had seen the man who could tame tigers with a whip, so that the children sitting at the front could come into the ring and stroke them on their heads, as they purred like kittens, and we had seen the women who could bend their bodies as though they were made of rubber and not flesh and bone. We had already seen all that.

Then it was the turn of the clowns. They had already appeared at the very beginning as the ringmaster was welcoming us to his circus, telling us of the things that were in store for us that evening. They all came out long before they were supposed to, interrupting the ringmaster's discourse. They didn't even have to do anything or say anything for everyone to start laughing. The ringmaster chased them round the ring, clobbering them with a big stick, and I laughed so much that

my stomach ached, and they all took a bow, and the band started playing, and the night had begun.

When the clowns came on again it was almost at the end, all that was left was the flying trapeze. There were two of them, and they came out with ladders and buckets as if they were going to decorate a house. One of them was wearing bright green overalls and a hat with a flower on it, the other one was wearing striped overalls that were far too small for him, and shoes that were too big. That alone was enough to make us laugh. They had laid a piece of plastic sheeting on the floor, which they tripped up on with every step, spilling the water in the buckets which they were carrying, so that the plastic sheet was soaked in no time at all. The band played their instruments fast and loud, and every time the clowns slipped and fell, the cymbals sounded and we all laughed.

A dwarf wearing white overalls and a cap came out to inspect the work they were supposed to have done, and when he saw the mess that they'd made, he held his little fist up in the air and started jumping up and down on the spot, but the clowns didn't even notice him because he was only a little person, so the dwarf stamped on the foot of one of the clowns, and the cymbals crashed as he did. The dwarf laughed to himself and to the audience, holding his stomach because he was laughing so hard, the clowns started to chase him, but the plastic sheet on which they were standing was soaked with soapy water, and they couldn't take two steps without slipping over, and their shoes were so big and awkward they just made things worse, and we laughed so hard that we held on to our stomachs, just like the dwarf had done.

Then the rumbling noise began. It got louder and louder as if there was a train coming straight towards us. The clowns fell this way and that on the sheet of slippery plastic, the dwarf ran out into the audience, and we all thought that it was still a part of the act, then the music became strange, and it faded altogether, and people stopped laughing, and the clowns were genuinely trying to escape but they couldn't because of their shoes, and because the sheet of plastic was so slippery. And still, here and there, some people laughed.

The whole world started swaying from side to side, people came off their seats and other people started screaming. By then nobody was laughing any more. The poles groaned under the strain as they swayed this way and that, like treetops in a gale. The cables and wires that held the poles in place started to snap one by one, making the same noise that the man with the whip had made when he was taming the tigers to be as docile as kittens, and everyone was screaming and trying to get away as, one by one, the things that had been supporting the tent started to fall on top of our heads. The smaller poles at the edge of the tent started to fall, people tried to run away from them as they did, but inevitably some got caught under them and were knocked down to the ground in an instant, their necks and backs and heads broken. The bigger poles that took all the weight of the tent leaned further and further until they could lean no more, and they too fell one by one.

Then the rumbling stopped and the earthquake had finished.

But all the things that held up the tent had now collapsed, and so the canvas began to cave in on top of our heads, slowly and peacefully like when you throw a clean sheet over a bed and it floats in midair before making its way slowly down to the mattress. We all ran as fast as we could to the exits before the whole canvas came down on top of our heads, but somehow the animals had got loose from their cages, and they ran side by side with all the people in the direction of the exits. They say that animals can sense an impending earthquake, and they say that the circus animals are the most intelligent animals of all, but even they didn't know what was coming that night. The monkeys howled just like children, and the ponies ran round and round, as though that was the only trick that they knew. The bears were trying to get to the exits running on all fours like bears out in the wild except that they still had their party hats on their heads, and the tigers were no longer like kittens, they all descended on one of the children who had earlier stroked them. They tore the skin from his flesh so that he was covered in blood in an instant and everyone was screaming at the top of their voices trying to get away from the animals and the canvas that was falling on top of our heads,

and for once it was the animals that were free and the people who were trapped, and not the other way around.

I was sitting high up when the earthquake struck, I was almost at the back, almost at the top of the tiers of seats. The terraces on which the seats were built shook all of us from side to side, like the rides at the funfair that are designed to do that very thing. Except that these seats were not designed to do that at all, and the whole thing started to cave in, first at the front and slowly towards the back, and of course the further back you sat, the further you had to fall. We crashed to the ground in no time, the metal supports bent out of shape like they were made of liquorice and not metal. We all tried to stand up as though that would save us but the ground was shaking so forcefully under my feet, and all I could do was sit there and watch these things that were falling down onto people's heads all around me, hoping that nothing would fall onto mine, holding my hands above my head as if they alone could save me. And people were screaming, bears were growling, monkeys were shrieking and dogs were barking and children were crying, and things were falling all around us, but nothing fell onto my head, thank God.

Only once the ground had stopped shaking could I stand up. The circus tent was still caving in around us, slowly and peacefully, as if there was no menace in it, and I couldn't tell how close it was because there was so little light left. I had to get out through one of the exits or else I'd be lost in there forever. But I could hardly see the exits because the whole tent had lost its shape, and the air felt heavier and heavier because it was being compressed by the sinking canvas. I had to step over so many bodies to get out, covered in blood and you couldn't tell if something had fallen on top of them or if they'd been mauled by the tigers and the bears on their way out. Some of them were calling out for help, but there was nothing I could do to help them.

Just as I reached the edge of the tent, a woman lying on the ground grabbed the bottom of my trousers, I tried to pull away from her, but she wouldn't let go of me. 'Please help me,' she croaked. The woman was lying under a pole that had

fallen over her legs, her skirt was pulled so far up that you could see her underwear. Her tights were torn from top to bottom, but somehow they still clung to her legs. 'You've got to help me,' she sobbed, 'I'm begging you.'

I managed to push the pole so that it rolled off her, like a rolling pin flattening dough, it slid onto another woman who was lying next to her, who must have been dead because she didn't even flinch when it rolled on top of her. I took the woman's hand and pulled her from under the canvas so that her head was outside the tent and her body inside, then I pulled up the canvas and ducked through it myself, so that finally I was out into the open air, and could breathe the air outside and not the humid heavy air that was inside. I took a deep breath and took hold of the woman's arms and pulled her out from under the tent until only her feet were inside.

'You've saved my life.'

I gave one last tug and her feet came out from inside the tent, one of them with a shoe and the other without, and her skirt had slid away from her altogether and was nowhere to be seen.

'Can you stand up?' I asked her.

'I think so.'

I held out my hand, which she took in hers and she slowly raised herself from the ground, and she turned out to be taller than I imagined, much taller than me, she had a big nose and blonde hair that was caked in blood. 'I've lost a shoe.' She tried to crawl back into the tent.

'You can't go back in there.' There were people crawling from under the canvas into the field wherever they could find a space. They were bloodied and sobbing and no one in their right mind would have gone back for a shoe.

'But I've lost my shoe,' she pleaded, although she said nothing about the skirt she'd lost, even though she was standing there in her underwear and tights that were torn to shreds.

'Get away from there,' I took hold of her arm and began to lead her away from the tent.

There were people crawling all around us, throwing themselves onto the ground, unrecognisable from all the blood on

their faces from the things that had fallen onto their heads, praying out loud, thankful that God had spared their lives. The heel of the woman's shoe kept getting stuck in the soft ground, and she made me go back for it even though she only had one left, and it was that more than anything else which made it hard for us to get away. I left her on a bench at the edge of the park where the circus tent had been erected, she had lost her skirt, one shoe, she had blood on her legs and on her hair, but she was still alive.

'You saved my life, do you know that?' she took my hand and put it to her face, and my eyes filled up with tears so that I could hardly see her any more.

'I didn't do anything, all I did was . . .'

'You saved my life, that's what you did.' The woman stood up and started hobbling back towards the tent, one shoe on, one shoe off, half naked and blood all over her face, 'And I'll never forget it.'

'Where are you going?' I asked her.

She stopped and took off her shoe so that she could walk properly, 'I'm going back for the other one,' she said, 'they're the only ones I've got.' She waved at me with her shoe still in her hand.

Slowly my eyes cleared and I could make out the buildings at the edge of the park, and the city in the distance. Sirens screeched near and far, people groaned and cried in all directions, helicopters roamed in the air above our heads. Fires roared throughout the city, and there were loud crashes of buildings which had become so weak from the movement of the earth that they could stand up no more, they fell to the ground sending dust flying in all directions.

Everybody who was not at home when the earthquake struck, started to make their way back to see if it was still standing and if the people that they loved were still alive. As soon as I reached the road by the side of the park, I heard crying coming from the rubble of an old house, the front of which had collapsed onto the street, the roof was now where the door had been and the door was nowhere to be seen. It sounded like a child crying out for help, and I thought that I

could save that child's life the way that I had saved that woman's life. I scrambled on top of the rubble and pulled off as many things as I could, but the crying was coming from under a whole section of the roof, which I would never be able to lift by myself. I heaved and heaved, but it just wouldn't budge, I called out to people in the street and a middle-aged man in a coat that was covered in dust came to help.

'You take that end and pull,' I said to him, as we listened to the child whimpering underneath. The man had big eyebrows that hung down over his eyes which were as dusty as his coat. He raised them as he heaved, his face turned red from the strain, and finally the section of the roof began to move and we lifted it clear of the child. But as we raised it, we saw that the child underneath who had been crying wasn't a child at all, it was one of the baby bears from the circus; and I couldn't say exactly how the bear had got there in the first place, but it was definitely one of the bears from the circus and its fur coat had blood all over it. The bear looked at us and growled in a way that was not like a baby bear at all, but like an adult bear. They say that animals are more scared of people than we are of them, but the hairs on the back of my neck stood on end, and the man looked at me and I looked at him, and we both dropped the roof at the same time and ran for our lives all over again.

When I reached home my grandfather wasn't there. Our things had been thrown all over the place, as though somebody had broken in. All the things that had been visible, things that had lined the shelves and the tables and the surfaces on which things are displayed, were now hidden away under all the other things that had come to the surface, things that I didn't know we had, things that belonged to my grandfather, funny little things that you would never imagine, and I had to hop over all those things just to get from one room to the next. I called out to my grandfather, but got no answer. I looked in all the rooms, and he was nowhere to be found, I asked everybody in the building if they had seen him, and nobody had, I asked in the bar opposite, but they hadn't seen him either, and Mrs Roman hadn't seen him, nobody had seen him, and none of us would ever see him again.

At the police station they were putting together a volunteer force to help find people in the rubble, there was a form that you had to fill out and have signed by your manager at work to excuse you from not being there. I took the form from the police station when I was queueing to register my grandfather missing and filled it in that same night, and once Mr Banos had signed it I would be able to help pull people from the rubble and save lives, just like I had saved that woman's life at the circus.

The scientists and the experts predicted that there would be another earthquake, they couldn't say when and they couldn't say how big but they said there would definitely be another, so the next few days people slept in the streets away from buildings just in case it came in the night. But the man on the radio said that we shouldn't panic, he said that we should carry on with our lives and go back to work on the Monday after the earthquake and do all the things that we normally did, as though nothing had happened, and in the end that's exactly what we all did.

On the first day back at work, everyone greeted each other with hugs, some people cried, and some people were not there at all, everyone talked about what had happened, and very little work was done on that first day. I held that form in my hand all morning, and everybody asked me what it was, so I told them that I needed Mr Banos' signature so that I could be excused from my work and join the volunteer forces, but nobody had seen Mr Banos all morning.

We were all called into a large room, and a man with a moustache and a long blue coat who I had never seen before, stood up at the front and addressed us. 'It's my sad duty to inform you that Mr Banos was one of the many who died in Friday's earthquake.' He had his hands in the pockets of his coat. Everybody started talking amongst themselves, and the man took his hands out of his pockets and signalled for us all to keep quiet. 'I'm sure we will all remember him with great affection and respect. I can say from my own experience that I found him to be a very efficient administrator and a kind man,' he said, 'and I would like us all to observe a minute's

silence not just for Arthur Banos but for all those who lost their lives in the earthquake.'

We all bowed our heads and thought about all the people who had lost their lives, but before the full minute was up, the man started speaking again. 'To replace Mr Banos we have asked Daniel Ferrer and he has kindly accepted.'

We were all shocked because Daniel Ferrer had been a nobody up until that moment. He had worked in the post-room and been an office boy, and if anything he was known for being lazy and dirty and semiliterate, and you could hear people talking amongst themselves.

'Please show your support for Daniel Ferrer, who has taken on this job under very difficult circumstances.' The man started clapping his hands, and we all had to clap as well. Mr Ferrer stepped to the front, the man shook his hand and then stepped out of the way so that he could address the workers. He was wearing his trademark dirty shirt that had been white but was now grey, and that he wore four days out of five. Under the circumstances we could excuse his appearance, but Daniel Ferrer came into work every day like he'd just escaped an earthquake or some other natural disaster, and God only knows why they chose him to replace Mr Banos.

'I have taken on this job under very difficult circum-stances,' he said, which was exactly what the other man had said, who was standing behind Mr Ferrer, his head bowed, nodding in agreement as he listened. 'And we will all miss Mr Banos that's for sure,' he said, 'but I'm sure I have everyone's support when I say that . . .' he paused because he wasn't too sure what he was going to say next, the man with the mous-tache had stopped nodding, and looked poised to step in at any moment if Mr Ferrer floundered any further, '. . . that the only way forward from this tragedy is to carry on as normal, like nothing had ever happened, like it was all a bad dream.' The man with the moustache started clapping again so that Daniel Ferrer wouldn't embarrass himself any further, he held his hands high up in the air so that we could all see him, and we started clapping as well.

'Everybody back to work,' he said as he shook Daniel Ferrer

by the hand, and the special meeting was over. We all shuffled back to our desks dazed from all this news and Mr Ferrer's bizarre speech, but nobody could do any work that day, all we could think about was Mr Banos and all the other colleagues and relatives who had lost their lives in the earthquake, and what things would be like for us now that Mr Ferrer was our manager. And there was nothing left of Mr Banos' things, everything had already been taken from his office, as though they had known about the earthquake in advance.

I tried all morning to see Mr Ferrer so that he could sign the form, but he was busy talking to other people, and I couldn't get to see him until the afternoon. He had drawn the curtains to his office, which is something that Mr Banos never did, and it was difficult to get his attention because there was no door to knock on and you were never quite sure what he was doing on the other side.

'Hello Mr Ferrer, can I speak with you for a second?' I said through the material. I heard him shuffle things around like he was doing something that he didn't want anyone to see.

'Come in,' he said.

I pulled back the curtains and Mr Ferrer was sitting there, facing me, legs crossed, with a pen in his hand and a single sheet of blank paper on the desk like he had been waiting there for me all day. 'My name is Daniel Glick,' I said, 'congratulations on your new job.' I put my hand out to congratulate him.

'Thank you.' He looked at me suspiciously.

'I need you to sign this for me.' I held the form out to him with my other hand, Mr Ferrer looked at it but wouldn't take it.

'What does it say?'

'It's for me to join the special volunteer force that's been set up.'

'What special volunteer force?'

'They've put one together to help pull people from the rubble.'

'I'm not signing a form.' He moved forward in his chair and the springs inside the chair squeaked.

'But they won't let me join if you don't sign it.'

'The best way to help is to carry on doing your job as before.' He put his pen down on the desk to show that he would not be dissuaded.

'But they haven't found my grandfather yet, and I need to join so that I can help people. I've already pulled some people out from the rubble, so I know I can do it, I saved a woman's life at the circus and pulled a child from the rubble.'

'The best thing if you want to help them is to keep on working.' He tapped at his own desk with his knuckles and made a noise as if someone was knocking at the door.

'But Mr Banos would have let me go, I know he would have.'

'Mr Banos is no longer your manager,' he said, 'now close the curtain after you go. Can't you see I've got all this to do?' He pointed down at his desk with both hands, which only had a single sheet of white paper and a pen lying next to it which was about to roll off the desk, and I wondered if Mr Ferrer could actually read at all. He caught the pen as it rolled off the side of the desk, 'Go on,' he said looking pleased with himself.

Soon the rubble was cleared, they found people alive, they took them to the hospitals, and it was in all the newspapers every day and on the television and people talked about nothing else, they became heroes and received medals from the President. The dust settled and the fires were put out, and I had done nothing to help, and it was all because of Mr Ferrer and I hated him with all my heart.

The day after the policemen interviewed me about Marina I woke up aching all over. My arms were bruised, my neck was stiff and my chest felt tender when I touched it, but I raised myself from the bed and got my things ready for work, the way that I did every day. Except that on that day I was so sore, that it took me forever to pick up my clothes and put them on and get myself ready. Everybody on the train stared at me because all around my mouth the skin was bruised and swollen, like when you go to the dentist and they take out your teeth.

'You're late.' Mr Grisold was leaning against the wall, smoking a cigarette, and there was so much smoke all around him that I could hardly even see him.

'That shithead Daniel Ferrer came looking for you already.' Mr Grisold waved in front of his own face to disperse some of the smoke which hung in the air around him, but there was nowhere for the smoke to go because there were no windows in the basement and no air and no light.

'What did you tell him?' I could hardly get the words out because my mouth was sore and swollen.

'I don't say anything to that bastard, if I can help it.' Mr Grisold started to cough, he bent over, coughed into the ground and staggered to the middle of the room, then he straightened himself up, his face reddened from all the coughing. 'Why are you talking like that, what's wrong with you?' he came over to where I was sitting and got up close, 'what the fuck happened to your face?'

'Nothing,' I said, but Mr Grisold pushed my head back so that he could see it clearly, and I stared up at the tiles on the ceiling and the hairs in his nostrils, like when you lie back in the dentist's chair and they are about to pull out your teeth.

'Nothing?' he said, 'your face is a mess.'

'I got into a fight.' He let go of my head. 'Two men tried to rob me, but I wouldn't let them take anything from me.' I told him.

'These days, they cut your throat for the fluff in your pockets.' Mr Grisold shook his head from side to side, and took a puff from his cigarette.

'I wouldn't let them take anything,' I said to him.

'That's because you don't have anything for them to take.' Mr Grisold took the cigarette out of his mouth and laughed.

'You're late again Daniel Glick.' Mr Ferrer had come into the room and was standing right behind Mr Grisold, the smile disappeared from Mr Grisold's face from one moment to the next.

'Something terrible happened,' I said to him out of the corner of my mouth.

'What cock and bull story have you got for me this time?'

'He was robbed last night, look what they did to his face.' Mr Grisold held the cigarette by his side, away from Mr Ferrer, as though Mr Ferrer would never know that he was smoking,

even though you couldn't breathe in the room because of all the smoke, and even though that's all Mr Grisold ever did all day long.

'I wouldn't let them take anything from me,' I said to him.

'There's always something with Daniel Glick, I know him a lot better than you do,' he said to Mr Grisold who had taken a sneaky drag of his cigarette whilst Mr Ferrer had been looking away.

'But look at his face.'

'God knows what the real story is,' said Mr Ferrer. 'Whatever it is, you're going to make up the time Daniel,' he looked at his watch, 'an hour. And from now on I want you to report to me every morning when you arrive and before you leave at night, is that understood?'

I looked down at the ground and nodded my head.

'And you should think about cutting down on the tobacco, you can hardly breathe in here,' he said to Mr Grisold, then he was gone.

As soon as Mr Ferrer had left the room Mr Grisold put the cigarette back in his mouth and stuck his middle finger up in the air. 'I'll fucking smoke if I fucking want to, who the fuck does he think he is telling me what I can do, he can stick this job up his dirty little arse if he thinks I'm going to cut down, I'll be smoking in my fucking grave.' Mr Grisold took one puff after another from his cigarette and blew the smoke all around him in defiance, I'd never seen him so angry. 'Daniel Ferrer is a stupid fucking bastard, and I don't have to take any notice of what he says.' He took another puff from the cigarette even though it was now only the butt, Mr Grisold looked at it and threw it on the ground, and I'll never know how that man didn't burn us all to crisp.

'I hate him.' I said. 'I hate him, I hate him.' And I repeated it over and over until the sound of the words didn't mean anything any more.

'Shut up,' said Mr Grisold, 'you're getting on my nerves.'

'I hate him so much, I wish it was him that died in the earthquake instead of Mr Banos.'

'That's more like it.' Mr Grisold shook my hand because he had said the exact same thing the first day that I had started working there. Then he put his hand in his pocket and held out a cigarette so that it was right in front of my face. 'It'll make you feel better,' he said.

'I don't smoke.'

'Just take it.' He shoved it even closer to my face.

'But I don't smoke.'

'Don't worry about it,' he said, and patted me gently on the back, 'I don't even like that brand anyway, it's all yours my boy.'

I took the cigarette that Mr Grisold was offering me and I put it in my pocket just to keep him happy.

'Maybe you should grow a beard until the bruises heal,' he said. 'Your face looks a fucking mess.'

All day long I said to myself that I would get up from that stupid little desk, take my coat, leave the building and never come back, but I stayed there until the end of the day and I went up the stairs to report to Mr Ferrer, just as he had said.

Mr Ferrer was the only one left in that office, I waited behind the curtain in his office and I could hear that he was on the phone, but I couldn't make out what he was saying because he was whispering into the receiver even though there was no one else there, then I heard his chair creaking and he pulled back the curtain, and he saw that I was there. With the back of his hand he motioned for me to go away, but I wasn't sure whether he meant that I could go home or whether he just wanted me to wait for him somewhere away from his office. So I waited at my old desk until he came off the phone.

'What are you still doing here?' He asked when he had come off the phone.

'You told me to report to you at the end of the day.'

'I just told you to go home,' he said. 'What's wrong with you, don't you understand anything?' He said the words slowly, one at a time, as though I was stupid, and you could see his rotten crooked teeth because he was moving his lips so slowly, and I was gone before he had even finished speaking.

I can't tell you how much I hated Mr Ferrer at that

moment. As I walked down the stairs and out of the building, I said to myself that I would never go back in there, and I didn't care what Mr Ferrer said or Mr Grisold or what anybody else said, and this time I meant it.

I was still saying the same words to myself when I left the building. A man who was standing just outside stared at me the whole time because I was mumbling to myself. I assumed he was a beggar because he was so unshaven and because he was just leaning against the wall for no good reason. He wore a coat that was so big for him that the sleeves had to be folded back, and even then you couldn't see his hands. I put my own hands in my pockets as I passed and he must have thought I was going to pull out a coin to give him, but instead I gave him the cigarette that had been in my pocket all day long since Mr Grisold had given it to me. I handed him the cigarette, and even though the sleeves of his coat had been folded back, they were still too long for him and he held out his hand to take the cigarette and all you could see were the tips of his fingers. He looked like he was on the verge of saying something, but he never did. 'That's all I have,' I said to him, and carried on walking.

I couldn't face going back to the flat with the floorboards pulled up and all my things strewn around the place, instead I went to the train station and bought a cake from a woman outside whose hair was so greasy that it almost looked wet, it stuck to her head like a damp rag, and she put her fingers through it when she saw me looking at her cakes.

'Which one for you this evening?' she asked, as though I was there every night.

She kept the cakes in an old fishtank which was covered with a plastic bag so that the flies and the rain couldn't get in, but all the cakes were covered in a layer of fine white sugar, as though snow had got in where the flies and the rain couldn't. I came a little closer and pointed to one that was in the shape of an ice-cream cone and had yellow cream inside. The woman was little and round and wore an apron with a pocket at the front that was heavy with coins.

'What happened to your face?' She pulled the plastic bag away from the top of the fishtank, and she was so short that

she had to stand on the tips of her toes to reach into the tank for the cake that I had pointed out to her.

'I got into a fight.' I took a coin from my pocket and blew on it to remove all the bits of tobacco from the cigarette that Mr Grisold had given me.

The woman shook her head from side to side.

'Two men tried to rob me and I fought them off.'

'You poor thing,' she said, putting the coin into the large pocket of her apron, 'be careful that the cream doesn't fall off on to your shoes.'

'But I wouldn't let them take anything from me, that's why they did this to me,' I pointed at my face, 'they didn't come off much better.'

'And there were two of them and only one of you.'

I nodded my head.

'You're a very brave young man,' she said, 'I would have run like the wind if I was as young as you.'

I shrugged my shoulders and started to walk away.

I took the cake into the station, and bought a coffee that was so hot that I could barely hold the cup in my hands, I sat on one of the benches and blew on the coffee to cool it down and blew on the cake to take off the fine white sugar that sat on top.

Everyone was standing in front of the big boards that tell you when your train is due. On the left was the board for departures, and on the right for arrivals, the words were written in large letters above the board so that you knew which trains were coming and which of them were going. Between the two boards was a huge clock that had stopped at twenty minutes past eight like so many of the other clocks in the city. It was bad luck to fix clocks that had stopped during the earthquake, you had to keep an eye on them because they would start ticking again when the next earthquake was due, that's what everyone said. There were other clocks in the station that told the time, some of them were fast and some were slow, but roughly they told the time.

The same man who had been begging outside the building where I work was now in the station, he was staring right at

me, and I recognised him straight away because his coat was so big for him that you could hardly see his hands out of his sleeves. He didn't look away when I saw him, he just kept on staring because he had nothing to eat. I finished the cake and blew harder on the coffee before taking a sip, but even then it burnt my tongue and the inside of my mouth, which was already cut and bruised from the night before. I felt the burn on my tongue for the rest of the day and the day after that, and I kept scraping my teeth against it all day long but the burning sensation wouldn't go away.

I walked out into the busy square in front of the station, full of buses and stalls and children and thieves, and I should have gone home but I still couldn't face going back there. I walked towards the centre where they were erecting new buildings that would be safe from earthquakes; the buildings were new and shiny and they reflected the traffic, the sky, the people, me, and all the things around them, and that's where I saw that man again. It was the same man who had been staring at me in the station, and now he was following right behind me, I saw him reflected in one of the those new buildings. He was short like me and had brown hair like me. I looked back just to make sure that it was him, and it was definitely the same man from the station, and how strange that in such a big city you should look back and see the same face twice, even on the train you take at the same time from the same place every morning and every evening, you never sit next to the same person twice, and if you do see the same face twice in the same day, there must be a reason for it, I said to myself.

The man who was following me wasn't a beggar at all, but a policeman, and I had that pang in my stomach that you get when you know that something is wrong. He was watching me wherever I went because the police didn't believe a word of what I had told them, they still thought that I had done something to Marina. There could be no other reason. We had all heard stories about how people are followed by the police day and night, and they ask their neighbours to report the things they hear and the things they see, and the neighbours oblige because that is how things are here, and one

day they come to take them away and they are never seen again, just like they did with my mother and father.

The man followed me all the way back to the street where I live, he waited outside at the end of the road, under the sign that tells you the name of the street, and I watched him from my window until he was gone.

I didn't go to work the next day, just as I had promised myself. I didn't set the alarm so that I wouldn't even be tempted. I woke up late and got dressed and went to the market, and everything was strange because that's the time that I'm always at work, and it felt like the weekend had come early, or like I was on holiday. I saw that man again, he followed me everywhere I went that day. I saw him at the market and he watched me as I looked at all the stalls, he was wearing the same long coat and that same serious expression on his face, and everything I did must have looked strange to him because he made me so nervous that even the simplest things seemed awkward and difficult just because he was there, watching me to see what I would do next.

My neck was so stiff that I could hardly turn round to see if he was still following me, but he was never far behind; he waited outside shops and somehow picked me out in crowds, at the train station, or at the covered market near where I live, and just when I thought that I had lost him, he found me again, and I had to keep telling myself that I had done nothing wrong, and that I had as much right to be in the market or at the train station as anyone else.

He followed me for two whole days waiting to see what I would do, and I did nothing but wander round because I didn't want to be at home. I sat at the train station and ate the things that I bought at the stalls outside, I watched the people come and go, I wandered round the parks and sat on the benches and watched the leaves fall from the trees. I walked through the leafy neighbourhoods near the former royal palace where the streets are named after painters and the houses are old and decrepit but look like small palaces themselves, walked to the big roundabout that is the very centre of the city, in the middle of which is a fountain that is lit up at night,

and is in all the postcards like the opera house and the cathedral, and to the streets just north of the centre where all the foreign restaurants and hotels are found and where neon signs blaze their names in colours after dark and where the traffic never stops day and night, and to the square in front of the Grand hotel which has seen better days and which is now where the prostitutes sit in the bar and entice foreigners or anybody with more money than sense. And everywhere you went in the city there was still the rubble from buildings that had collapsed, and buildings that were abandoned because they were no longer safe to live in, and you would be forgiven for thinking that the earthquake had struck a few weeks ago and not a year and a half ago. I wandered around all those sights from one to the other like a lost tourist, and each time I looked behind me the man was still there. At night he followed me all the way back to the street where I live, he stood under the sign that tells you the name of the street and waited for me to push the front door open and walk up the stairs to my flat, and only then would he disappear.

On the third night it was colder than it had been the nights before, I could see his breath in the cold air and he must have seen mine. The glass front of the bar across the street from where I live was dripping with condensation, so that you couldn't actually see into the bar; droplets of water trickled down all the way to the bottom, and at the top was a little circle that had been cleared by the bartender so that he could keep an eye on the things that happened on the street, the way that he did every day. Suddenly I remembered that the bartender stood there all day long, that he had seen my wife putting things into that car every day, and that he could tell the police everything that he had seen, so that they would leave me alone once and for all.

I turned back towards the bar and pushed the door to get in. There were three old men playing dominoes at a table towards the back, cigarettes in their mouths and a cloud of smoke above their heads, they all looked up when I came in.

'What happened to you?' asked the bartender who came out from the behind the bar when he heard me come in.

'I got into a fight,' I told him, once I had finally closed the door.

'Yeah, with your wife,' said one of the old men at the back of the bar, and all three of them cackled to themselves.

'You saw my wife put things into that car, you told me yourself that you saw her do it every day.'

'You didn't tell me she was your wife though, did you?' he said. 'I only found out afterwards.'

'The neighbours think that I did something to her, and they called the police.'

'It's what you didn't do to her that's the problem.' One of the three old men called out, and again all of them laughed, harder than they did before. One of them had no teeth in his mouth and all you could see were his gums, he laughed so hard that tears trickled down his cheeks like the drops of moisture that trickled down the window at the front of the bar, and he had to wipe them away with the sleeve of his jumper.

'Don't worry about them,' said the bartender, but I could see the teeth in his mouth that leaned backwards and forwards because he too thought that what the old man had said was funny. 'They don't mean anything by it, they're just crazy old guys who can't hold their drink.' He looked straight at them when he said that.

'Who can't take their drink?' Said one of them, highly insulted. 'Bring on another round.' That was exactly what the bartender hoped they would say, he went behind the bar and poured out three glasses of that homemade brandy that he had given me when I was last there.

'You have to tell the police what you saw, they won't believe me, they think I did something terrible to her.'

'The police did that to your face didn't they?' he said after he had taken the drinks to the old men.

I nodded my head. 'You'll have to tell the police what you saw, I'm afraid they'll do this again.'

'I already told them everything,' he said. 'They came round the same night they took you away and I told them everything then.'

'But they follow me all the time to see what I'll do next,

always the same man, he's dressed like a beggar but he's a policeman, who else could he be?'

'Why would they want to follow you if they know you didn't do anything to your wife?' he said.

'Everyone knows he didn't do anything to his wife.' Again one of the old men called out and all three of them started laughing.

'I'm telling you there is someone following me.'

'That one is a liar just like his grandfather.' One of the old men called out, he threw his head back and poured in the last of the brandy from his glass and brought it back down onto the table with a thud.

'I never knew anyone to cheat at dominoes like his grand-father,' said another one.

'I promise you there is someone following me, you must have seen him from here,' I said to the bartender. I moved forward and looked through the little circle that the bartender had cleared in the window, but the circle had now fogged up along with the rest of the glass pane, and you couldn't see out into the street, I put my sleeve against it and wiped more of it so that I could show him the policeman who had been follow-ing me for days. But even after wiping it with my sleeve you couldn't really see the end of the street from there. I pulled at the door, and it opened the first time, I stood out in the street and looked under the sign that tells you the name of the street, but he was gone. I waited there for a moment and caught my breath and looked around me but there was no one there. I rushed back into the bar.

'He's there at the end of the street, you can have a look if you don't believe me,' I said.

'You bring shame on your mother and father with your lies,' said one of the old men.

'I promise you I'm not lying, you can have a look, he's there at the end of the street, under the sign.' I pointed behind me towards the street, but nobody even moved inside the bar because they were all convinced that there was nobody there.

'You're a stranger to the truth just like your grandfather.' All three men started chuckling to themselves again.

'Well if there is someone there, it certainly isn't a policeman,' said the bartender.

'Maybe it's Santa Claus, to give you an early Christmas present,' said one of the old men. He took the cigarette out of his mouth and tried to make a whistling sound but nothing came out because he had no teeth in his mouth, so the other two started whistling Jingle Bells for him, but they started laughing so hard that they couldn't whistle any more. The bartender tried not to laugh with them, you could see he was really trying hard not to laugh, but in the end he just couldn't help himself. He covered his mouth with his hand so that I couldn't see where his teeth were all crooked and crammed into his mouth, where they leaned backwards and forwards, this way and that, like old forgotten gravestones in a cemetery.

Four

Whoever he was, he followed me wherever I went. I hurried through the streets as fast as I could, as though I was late for an appointment, but every time I looked back, he was still there. Like the children outside the train station who follow you for miles until you give them a coin; you can walk as fast as you like and curse them as loud as you like and as colourfully as you like, but in the end you give them the last coin in your pocket so that they leave you in peace.

He looked a mess; he hadn't shaved for days, just like me, he was short like me, and had brown hair like me, maybe a little older than me, but I couldn't say exactly because he hadn't shaved for days, just like me. Now that I thought about it, he didn't look anything like a policeman, he hobbled like an old man, as if his shoes were full of sharp little stones that cut through his socks and into his feet with every step that he took, and when he walked he kicked the bottom of his coat, which seemed to get longer and longer every time I looked back at him. And still somehow he kept up with me.

I said to myself that if this man didn't stop following me, I would go back to the police station and make a complaint about him, although the police station was the last place that I wanted to be. I walked round and round in circles, nearer to the police station and then further away again, and I knew I was never actually going to go through with it. I walked down the same streets and passed the same shops over and over, trying to summon up the courage to go, but I just couldn't.

'Daniel Glick, is that you, under all that beard?'

It was old Mr Murch, the barber I used to go to after the earthquake when I made the trip to the police station every other day to check for news of my grandfather. He cut people's hair at a discounted rate after the earthquake, and he said himself it was the busiest time he'd ever had, but then his prices went up again and there was no point in coming all the

way here for a haircut. 'Is that you walking aimlessly up and down my road, I hardly recognised you with all that hair.' He probably said that to all the passers-by, to scare them into having their hair cut.

'Does it look that bad?' I said.

'Come in and have a look if you don't believe me.' Mr Murch led me into his little barber's shop, he put his hands on my shoulders and steadied me right in front of one of the triangular mirrors. 'When's the last time you actually looked in a mirror?' he asked.

'I can't even remember.' He was right, my hair had grown long and messy and I hadn't shaved for days, I looked more like the man who was following me than myself.

Mr Murch was a nice old man with a grey moustache which became longer and thinner when he smiled, he patted the big red chair that I used to like so much because it was like the dentist's chair where my father used to work. 'You're way overdue,' he said.

Once he had enticed me onto the red chair, Mr Murch didn't say very much. He took a brown cape and flung it in the air over my head with the grace of a bullfighter in the ring, because he had been doing this for most of his life and tucked it into the collar of my shirt, he took scissors from a drawer and a comb from his pocket.

From where I was sitting I could also see the man outside reflected in a corner of the mirror, standing against the wall on the other side of the road, peering into the barber's shop as though he'd never seen anyone get their hair cut before. The barber moved my head gently this way and that, to get at the different parts of my hair, at the back, at the front and at the sides, but I kept moving my head back so that I could keep one eye on the man outside. I did it without even realising, and Mr Murch kept moving my head back to where he wanted it so that he could continue cutting my hair. When he had finished, he brushed the hairs from my collar and sprinkled powder on my neck, then held another mirror to the back of my head.

'You like it?'

I nodded my head, 'A definite improvement.'

'Now what about all this?' He rubbed his hands over the bristles on my face. 'What's all that about?' he said.

'Maybe it could come off as well,' I said wondering if the bruises underneath had disappeared. That was all the confirmation he needed. He pulled a special handle on the chair and it began to lean further and further back, and I leaned back with it until I could hardly see the mirror any more. He put a hot towel on my face and then lathered it before scraping the blade against it, and all the time I kept trying to raise my head a little to see if the man was still watching me, but the barber pushed my head back and continued to shave me, and the more he pushed me back, the more I tried to raise it so that I could keep an eye on what was happening outside. In the end, the barber's blade nicked the skin just by my ear. He stopped what he was doing immediately. I sat up slightly and we both looked into the mirror waiting for the spot of blood to appear through the white of the lather, and eventually it did.

'I'm sorry,' I said to him, as though I had cut his face and not the other way around.

'Why can't you sit still for a moment Daniel?' The barber looked at my reflection in the mirror and I looked at his, so that we weren't really looking at each other at all. 'Why are you so nervous, are you worried I'm going to cut your throat?' He took some cotton wool and pressed it against the cut so that it would soak up all the blood. 'I've been doing this longer than you've been alive,' he said, slightly offended.

'It's not you Mr Murch, it's that man standing outside, the one with the coat,' I said, 'he's been following me for days.'

'What for?' he asked, trying to get a glimpse of him.

'I've no idea, but I'm going to report him to the police,' I said.

'That man there?' The barber started to laugh. 'You're nervous about him? What's he done to you?' He put his hand on my chest and pushed me back in the chair. 'You need to relax Daniel,' he said, and he continued to shave my beard.

'You don't believe me,' I said, sitting up again.

'The police make more problems than they solve, that much I do know.' The barber pushed me back down again.

'But he's been following me for days, I can't get away from him, everywhere I go he's there.'

'Look at him,' he pointed to him with the razor in his hand, 'he's harmless. Now sit still and relax so that I can finish, or this time I might just accidentally cut your throat.'

Once he'd finished, he took a little white towel with which he wiped the remaining soap from my face. The bruises around my mouth had almost healed but they were still visible.

'Don't tell me he did that to your face,' he said, when he had cleaned all the soap off.

'Two men jumped me the other night, but they never managed to take anything in the end.'

'And you're worried about him out there.' He moved my head gently round so that he could have a good look at it. 'Didn't he do anything to help?'

'He wasn't even there.'

'Well next time, at least it won't be two against one,' he said, 'he might actually be looking out for you, did you ever think of that? Although he doesn't look like he'd be much help, two is always better than one.'

'I'm going to the police anyway.'

'Why don't you just leave him, it's a free country isn't it?' He laughed to himself. 'Look at him he's harmless, he's got nothing better to do, that's all,' he said. 'We had someone like that in my town. He was like the village idiot, he followed all the children round and they threw stones at him, but he followed them anyway, and he never meant them any harm, he just had nothing else to do.' The barber took the cape out from my collar where he'd tucked it in and stepped out into the street to shake all the hair from it and to get a better look at the man.

'Why doesn't he follow someone else instead of me?'

'Maybe it's because you two look so alike.' He came back in and hung the cape back on the hook, and took my coat from the other hook.

'I don't look anything like him.'

'You did with all that stubble, why don't you treat him to a shave and see for yourself.' He laughed.

'I'm not treating him to anything.'

He held my coat out for me, and I stood up from the big red chair and tried to put my arms into the sleeves without looking, and it took me awhile to get the first arm in, but the second arm I couldn't fit into the sleeve at all.

'Just relax Daniel.' The barber took my arm and fed it into the sleeve himself, as if he was dressing a dead person. 'He's perfectly harmless.' I put my hands in my pocket and gave him all the coins I had and left. 'And, don't leave it so long next time, you don't want to go round scaring people.'

Old Mr Murch was right, the man was harmless. He trailed behind me like an old dog and watched everything I did as though he had never seen anyone do it before, just like a village idiot, and I didn't have to hurry through the streets to get away from him. I could take my time as if I was strolling through the gardens by the former royal palace on a Sunday afternoon. But there were hairs in my collar that rubbed against the back of my neck every time I turned back to look at him, they had some-how got in there, even though the barber had tucked that cape into my collar and brushed my shoulders at the very end. I unbuttoned my shirt at the top, but even so I could feel the little hairs rub against my neck, and the more I walked, the more they itched, not just round my collar but on my back and then my legs and then everywhere. I hurried through the streets all over again, back to my house to change my shirt for another, and the village idiot followed me all the way, and he must have wondered to himself what was going on.

The old people were on the stairs again, walking up and down for exercise. You could hear them huffing and puffing in the dark, you could hear the stairs creaking under their weight, and their feet sliding onto each step, as if they had only just made it. I passed an old man who was almost at the bottom, ready to turn back again, his face was wrinkled and gaunt and you could tell that he had no teeth even before he spoke. He was wearing his dressing gown and a pair of slippers that were so big for him that with each step they dangled from his feet in midair and it was a miracle that he managed to keep them on his feet at all.

'Good afternoon,' I said to him. But the man was concentrating so that his slippers wouldn't fall from his feet onto the step below, because he would never have been able to pick them up again if they did. I stood by the wall and let him pass, and eventually he said something back, but you could hardly understand a word because he had no teeth left in his mouth.

I walked up another flight of stairs and there was Mrs Roman, huffing and puffing the loudest of all. She too was wearing her dressing gown, the cord that was supposed to go around her waist was trailing behind, two steps down from where she stood, I picked it up and held it out to her.

'Who's there?' She stared ahead of her, as though she thought there was someone in front of her and not behind.

'It's me, Daniel, I'm right behind you.' I stood closer to her so that she could see me.

'Why are you creeping up on me like that?'

'I'm not creeping up on you, I'm just walking up the stairs. I've just been to the barber's and I've got hair all down my back,' I said to her just to make polite conversation.

Mrs Roman looked at me and nodded her head slowly.

'He cut my face when he was shaving me.' I pointed to where the barber had nicked me with the blade.

'How am I going to see a small thing like that, when I can't see the step in front of me? Why do they never turn on the lights here? They must think we're all vampires.' She took the cord from me and tied it around her waist in a loose knot that looked like it would come undone again at any moment.

'It was only a small cut but it wouldn't stop bleeding,' I said to her.

'These young barbers don't know what they're doing, my husband could get a shave that would last him a fortnight.'

'Well this one was an old barber.'

'They're even worse,' she said, 'their hands shake so much that you're lucky to get out of there alive.' She held out the hand that wasn't holding on to the banister and we both watched it tremble. 'I couldn't cut your hair any more with hands like this, I'd cut your ears off without even realising.'

'He didn't charge me anything though,' I told her.

'My husband wouldn't let anyone but me near his hair.' Mrs Roman was getting all morose again. 'And now he's gone.' She took another step up and the knot on the cord around her waist came undone and fell to the side, just like I had known it would.

'You still have me Mrs Roman.' I wasn't in the mood to hear the same things about her husband all over again, and started to make my way up.

'You have your dog to look after.'

'What are you talking about? I haven't had the dog for years, don't you remember she ran away?'

'The puppy that we gave you?' She looked totally shocked at this news.

'You must remember, we looked everywhere for her, Mr Roman came with us.'

'No, you must find her,' she said, 'she'll protect your house and eat all the scraps of food so that you won't have to throw anything away.'

The old man in the dressing gown and slippers who had been at the bottom of the stairs when I came in had now caught up, and was standing a few steps below us waiting to overtake. He started to say something that neither of us could understand because he had no teeth in his mouth.

'What does he want?' asked Mrs Roman.

'I think he wants to get through.'

The old man took another step towards us so that he was standing right behind Mrs Roman.

'Let him pass then.' Mrs Roman pressed herself against the banister so that the old man could carry on walking up the stairs, but neither she nor the old man would let go of the banister for fear of falling over. The old man mumbled something again, and even though you couldn't understand him, this time you knew exactly what he was trying to say. Mrs Roman gripped the banister even tighter, with both her hands, and the old man couldn't get through. He started shouting something at her. I leaned over, took hold of the old man's wrist, pulled his hand away from the banister and led him up the stairs by the side of Mrs Roman. His wrist was so

thin and so frail that I could have snapped it in two without any effort.

'You've got the whole staircase to yourself now old man.' I let go of his wrist.

His face was full of panic. He rubbed his wrist with his other hand and pointed to the steps below, mumbling something about his slipper. When I looked down I saw that one of his slippers had come off his foot onto the step which he had been standing on. I picked it up and threw it onto the next landing so that the old man would have to get it himself.

'Go on,' I said to him, 'there's your slipper if you want it.'

The old man looked at my hand in the way that a dog looks at you when you throw a stick in the park, and it thinks that you're still holding onto it because it didn't see it fly through the air. He didn't have a clue where it had gone. I showed him my hands so that he could see that they were empty, and he got confused and tears welled up in his eyes because he thought that he had lost his slipper forever, and because maybe he'd heard all the terrible rumours about me.

'Are you blind?' I said to him, pointing towards the slipper, stretching out my arm as far as it would go so that the old man would see it. Once he focused on it he started to walk up the stairs, much faster than he had done before.

Mrs Roman was still gripping the banister with both hands.

'They need to put traffic lights up here for all you lot,' I said.

Mrs Roman looked at me as though it was me who had shouted at her, and not the old man. I handed her the cord that was trailing beside her from her waist. 'What's wrong with you?' I said to her.

'There's nothing wrong with me,' she said, 'it's you who has changed.' She snatched the cord from my hand.

'I've just done you a favour, that old man was a pain.'

'I've never seen you speak to anyone like that.'

'How do you want me to speak to him, he was half deaf anyway,' I said walking up the stairs to my flat, 'next time I won't even bother.' On the way up I had to pass the old man again, and when he saw me, he stood against the banister and

made himself as small as possible so that I could get through without even squeezing past, and I wish the village idiot had been there to see the look in that old man's eyes as I passed him on the stairs.

I had just turned twelve when I last saw my parents. After they left, I was so miserable that I even tried to run away to the circus, I couldn't think of anywhere else to go. Mr and Mrs Roman gave me a puppy to try and cheer me up. They brought it downstairs in a brown box, and I had to guess what was in it, but I couldn't have cared less what was in the box, and they did my guessing for me.

'Could it be a pair of shoes?' they said, 'A toy car? A storybook?' They used up all three guesses and they still hadn't roused my curiosity. They opened up the box and we all looked inside. The little black puppy sat in the corner shivering because it was scared, it got even more scared because the darkness inside the box had suddenly turned to light, but it didn't think to look up at us. The newspaper at the bottom was so wet that you couldn't read the words any more, you could only just read the headline. "*Factory Blast Kills 27,*" it said, but even that didn't seem as bad as my parents leaving.

'Will you look at that,' said my grandfather and from his tone we all knew he was going to say something sarcastic, 'we used to eat dogs in the war.'

'Speak for yourself,' said Mrs Roman.

'Don't give me that,' he said, 'everybody used to eat dogs, even the generals in the army used to eat them, they taste no different to pork.'

'You're just jealous because you didn't get one,' she said.

'What do I want with a little bag of fleas that shits itself all over the place?'

'Can you try and say something nice for once, you're spoiling it for the boy, he's upset enough as it is, can't you think about him for once.' Mr Roman shouldn't have attempted such a long sentence, he got stuck on every word he said, and by the time he'd finished saying it, we'd forgotten how it had started.

'What shall we call him?' Mrs Roman changed the subject.

Everyone then suggested people's names and I said no to all of them. 'It's bad luck to give a dog a person's name,' I said. 'Anyway, we don't even know whether it's a boy or a girl.'

My grandfather picked it up by the scruff of the neck so that he could check to see what it was. 'It's a girl dog.' He dropped her back into the box, the way you drop rubbish into a bin, but no one said anything to him, not even the dog made a sound.

Mr Roman was so angry with my grandfather that he and his wife left before we could even think of a name for her.

'Those two only give you things so that you will look after them when they're old.' My grandfather spoke so soon after they had left, that they could probably still hear him from the corridor outside. He copied the way Mr Roman spoke when he stuttered, and I wanted to laugh even though I knew it was wrong. He spat everywhere as he said the words, and his saliva went all over his shirt and all over me, although Mr Roman never actually spat when he spoke. 'Normal people don't go round giving presents to other people just because they live upstairs.' He wiped the spit from his face.

'When I get older I'm going to get married and have a family of my own.' I said.

'After I die you can do as you please, you can even look after those two if you want to.' He pointed up towards the ceiling. 'You can do what you please, and you can have what you please. You can even have my gold teeth,' he pulled his mouth open with his fingers so that you could see all his teeth and all his gums and carried on speaking like that for a little while, with his fingers pulling his mouth open, 'if you can pull them out that is. I don't have to buy you any puppies because you're my blood relative and so you have to look after me whether you like it or not.' He took his fingers out of his mouth and wiped them on my shirt. 'They already spoil you as it is.' He took the puppy out of the box again, and brought her right up against his face. 'You piss on the floor and I'll throw you out the window,' he said to her although his warning was for my benefit. Then he swung his arm round like a crane on a building site so that she was right over the box, and

he dropped her inside. He looked at me and I flinched as though he was going to take me by the scruff of the neck. 'And if she shits on my bed, I'll throw her into the river.'

The little black puppy was scared of me because she thought that everyone was going to pick her up and then drop her like a piece of rubbish. After my grandfather went to bed I took her out of her box and scooped her up carefully with both hands. I put her on the floor, gave her some bread and milk, changed the newspapers in her box, and all the time I was trying to think of a name for her, but I just couldn't think of anything.

After a few days she knew which one was me and which one was my grandfather. Whenever she saw me, her little tail stood up in the air and wagged from side to side, and when she saw my grandfather she watched his every move as if he was a cat. I kept her out of my grandfather's way as much as I could. I took her to the park every day and threw sticks up in the air so that she would fetch them, but she was still too small to fetch things, she just kept looking up at me as if I was the one who had to go and fetch the sticks and not her. And still no one had thought of a name for her.

One day I came home from the park with her, and I could tell there was something wrong as soon as I walked in the door. I remember the smell, and I remember the sound of flies buzzing around the whole flat, from one room to the next. My grandfather dragged me into the bedroom by my ear. 'Look what that dog has done on my bed.'

The dog had shat right in the middle of his bed, and you couldn't miss it because it was as big as if it had been done by an elephant, and not a little dog, and because it was right in the middle of his bed. 'What did I say to you about that little bitch shitting on my bed?' He shouted at the top of his voice so that even some of the flies that were on the bed, in the very centre, got scared and moved away, just for a moment, before they descended again.

'I'll clean it up,' I said to him.

'Well I'm certainly not touching it,' he said. 'I told you what would happen to her if she shat on the bed.' He pushed me a little closer to the bed and the dog started barking. He

picked up the dog, left the flat and that was the last time I ever saw her. I cleaned all the blankets and the sheets on his bed, but I knew that it wouldn't make any difference. When my grandfather returned to the house you could smell the alcohol on his breath and he was in a good mood again. He even started singing, but he never once mentioned the puppy, he didn't even tell me whether he had thrown her into the river like he said he would.

When Mr and Mrs Roman asked after the dog, I had to tell them that she had gone missing in the park and that I couldn't find her anywhere. Mrs Roman didn't say too much, she didn't get as angry as I thought she might because she had so many other things on her mind. She said that we should all go to the park and look for her. When we got to the park we started calling out to her, but we had never thought of a name for the dog so we didn't know what to call out, we just called out 'puppy' and 'dog', and we whistled, and made noises, and the people in the park must have thought that we were crazy people, and they kept as far away from us as they could. Even my grandfather had to pretend to look for her. He called out to her as if he really didn't know what had happened to her, and his performance was so convincing that even I began to wonder whether he had taken her to the river at all. Mr Roman thought that every dog he saw was my dog, even the big dogs, even the dogs that weren't the same colour, even large stones in the distance, he really was acting crazy that day.

'There he is, there he is,' he kept saying, pointing excitedly at things in the distance. After awhile, we didn't even look to see what he was pointing at, and anyway, the dog was a she and not a he, that much we did know.

It was about that time that Mr Roman started to get sick, and you could already tell that he wasn't right. Mrs Roman was more worried about him than she was about finding the dog. She wanted to make sure that he didn't stray too far or stay out too long, and that his scarf was wrapped tightly around his neck, and it wasn't even cold on that day. She was the one who decided that we should forget about the dog and go back home, and no one protested, least of all my grandfather.

The village idiot was standing at the end of my street, under the sign that tells you its name, waiting for me to come down as soon I had changed into a clean shirt after my haircut. He followed me relentlessly that day as he had done for the last week, except that now I was in no hurry to get away from him because he was harmless, just like old Mr Murch had said. I went into shops that I never normally went to, and spoke to the people who worked there which I never usually did, and I went to parts of the city that I had no business being in, just so that he could see, just so that he wouldn't lose interest and follow someone else instead.

Then it got dark, and I should have gone home like I would have on any other night. I got as far as the street where I live, and I think that I slowed down outside my block, and I think that I fiddled with the key in my pocket, ready to climb up the stairs and put it into the keyhole. I can't remember why I didn't go in, I just remember that I kept on walking, as though it wasn't the place where I lived at all. The way you ignore an acquaintance in the street when it suits you, when you can't think of a thing to say to them, you look straight ahead and pretend that something else has caught your eye, and they do the exact same thing.

Little drops of water fell from the sky. They hovered around the streetlights the way insects do in the summer. They were so small and fell so slowly, that I thought they would fly around forever, but they made their way to the ground and soaked it, and they seeped in through the holes in my shoes. I caught them on my sleeves and on my shoulders, and they moved from one layer to the next, until I felt the cold and the wet on my skin. The bells of a church chimed the hour, it was late, time to go home, but I just carried on walking south, towards the river, as though I was being tipped into it. Just as far as the bridge, I said to myself, then I would go home. All that time the village idiot kept up, in the dark and in the rain, straying further and further away from where he knew I should be, and he must have wondered to himself what was going on in my head.

The bridge is made of concrete and has grey metallic railings which keep you from falling over the side. In the

winter the railings get too cold to touch without gloves, and in the summer they get too hot, but they keep you from falling over the side. I looked over and saw the currents rush past like soup in a pot about to boil, swirling and bubbling. On the other side of the bridge are the factories that blow smoke from their tall chimneys, the smoke is as thick and as white as the clouds in the sky, sometimes it's so dense that you can't even see the sun. God knows what they do in there that it should spew out such dense smoke. Further on from the factories are the new dowdy suburbs they have built to house the people left homeless by the earthquake and by the bulldozers which have cleared whole sectors of the city to make way for the new enormous parliament complex. The blocks are all the same, rows and rows of five-storey buildings, that were put up so quickly that already they look like they have been through an earthquake or two.

I got as far as the middle of the bridge and waited for the village idiot to catch me up. Finally he appeared; his coat longer and heavier than usual, soaked through from the rain, and his head bent forward to avoid the spray that came at him from all directions. I started walking towards him and didn't stop until we were facing each other, studying his face to see if it really did look so much like my own, waiting for him to say something, but he stood there in silence looking at me in the same way that I was looking at him, neither of us daring to speak. His eyes were red and sore as if he'd been rubbing them all day long, and he had short brown hair like my hair, and he hadn't shaved for days, but if you looked into his face and imagined it without all the stubble, he did look just like me, like the old barber had said.

'My name is Daniel Glick,' finally I put my hand out for him to shake. His handshake was soft and lifeless like that of an old woman. The village idiot said nothing, he just stared and stared like he had seen a ghost. 'What about you?' I asked him, 'what's your name?'

The village idiot made sounds that were more like those made by an animal than a person, and I couldn't even begin to guess what he was trying to say to me.

'I can't understand you,' I said.

He shook his head from side to side and pointed at his mouth, which he then opened wide as if he was at the dentist. I saw his teeth and the inside of his mouth, I saw the silvery strings of saliva that hung in his mouth from the top to the bottom like the ropes in a circus tent that keep it from falling onto all the spectators, and I saw that he had no tongue. That's what he was trying to show me, and that's why he couldn't speak, and he really was just like a village idiot, harmless and stupid like the barber had said.

'What happened to your tongue?' I said. He put his hand inside his pocket and took something out to show me; it was the cigarette that I had given him when I had first seen him outside the building where I work, it was wet and soggy and falling apart, and God knows what that was supposed to mean. 'What are you showing me that for?' I asked, and I knocked it right out of his hand with my own, and the cigarette went flying up in the air, over the railing and down again, into the river. 'What do you think I want with that?' The village idiot had a look on his face like the whole world had ended and just seeing that pathetic look on his face made me want to do it all over again.

'Cheer up village idiot,' I said, 'it's only a cigarette, I don't even smoke, I don't suppose you smoke either.' He shook his head emphatically, pointed at me and then at himself repeatedly, trying to tell me something that I just didn't understand, something about him and something about me.

'What is it, what does that mean?' I mimicked his movements, prodding him in the chest and then prodding myself, and the village idiot was so weak and so spineless that he almost fell backwards onto his backside. 'Steady,' I said to him, and pulled him back up straight. The more I looked at him, the more he reminded me of myself, his brown eyes and his pointy nose, his heavy eyebrows that almost met in the middle, everything.

He put his hand in his pocket again and took out a piece of paper, and I don't know what came over me that night on the bridge but I knocked the paper out of his hand just like I did

91

with the cigarette, and it floated in the air, over the side and into the water just like the cigarette had done, and you should have seen the village idiot's face then. He protested, making noises and put his hand in his pocket again, and this time I slapped his face with the back of my hand, like the policeman had slapped mine when they were interviewing me. He didn't do anything, as I knew he wouldn't, he just had that wounded animal look on his face that made me want to do it again and again. He pointed at me and then at him like he had done before.

'Stop doing that,' I said, and hit him across the face again, but this time I hit him harder so that I could feel his teeth through the skin of his face, and his lips reddened from the blood that seeped through, like the painted mouth of a woman. 'Why don't you follow someone else?' I hit him again and again, around the stomach and on his face in a way that I had never hit anyone before, and he didn't lift a finger because he was just a village idiot who couldn't even put a sentence together, all he did was shake his head in disbelief, and make noises like the noises an animal makes. He fell against the railing and made himself smaller and smaller, until he was almost crouching on the floor, I kicked his head against the metal bars of the railing, and they vibrated making a sound like the rails at the train station when the train is about to arrive. He put his hands over his head to protect himself, but I kicked him over and over, like the policemen had kicked me when I was lying under the table, and the blood seeped through his fingers, and it was diluted by the rain that was still falling, so that it looked like the fake blood they use in the movies, and not like real blood at all.

'Stand up,' I said to him, and unbelievably the village idiot did just as I said. 'Why are you following me?' I asked. 'Why?' He started doing that pointing thing, first at me, then at him. 'Don't do that,' I said, 'that doesn't mean anything.' I pulled his hair so that his head leaned right back, and he didn't even struggle, he took out another piece of paper from his pocket and tried to hold it out in front of me, but I didn't even look to see what it was.

Tears streamed from his eyes into the blood on his face

already watered down by rain, so that it looked like tomato sauce and not the real blood of a real person. I pushed him against the railing and the village idiot lost his balance and almost fell over the side, he was still holding the piece of paper in one hand and just wouldn't let go. I pulled him up over the railing and he fell onto the other side, holding the railing, now with both hands, dangling off the side, crying and screaming like a wounded animal.

And I still don't know what came over me that night on the bridge, but I kicked his hands repeatedly so that he would let go and fall down into the water below. I kicked them so hard that I must have smashed his fingers in the process.

Finally he let go of the railings, first one hand and then the other, and the village idiot dropped into the river, into the water below that was swirling and bubbling like soup in a pot about to boil, and I heard the splash as he fell into the water. Then it was quiet again, only the railing still vibrated where I had been kicking it over and over, but that too slowly faded, like the rails at a train station after the train has just left.

Five

I ran all the way home and raced up the three flights of stairs to my flat, but I couldn't find the key to the door in any of my pockets. I climbed another two flights of stairs to Mrs Roman's flat and knocked on her door until I woke her from her sleep. I thought the knocking would wake all the neighbours, it echoed down the stairwell and up again, but everything remained quiet and still, as though the whole building had been abandoned. Finally I heard movement coming from inside; I saw the light come on under the gap in the door, and only then did I stop knocking. Mrs Roman whispered from the other side of the door without opening it. 'Who is it?'

'It's me Mrs Roman, Daniel.' I pressed my head against the door and spoke right up to it.

'It's one o'clock in the morning,' she said.

'Please open up, something terrible has happened.'

The door opened and there stood Mrs Roman. Her hair was dirty and tangled and as white as the clouds of smoke that billow from the factories along the river. She had put her husband's old coat over her shoulders, and you could just see her fingers emerging from inside it, clutching it tight from within so that it wouldn't open up and reveal the nightdress underneath.

'What do you want from me?' She stepped to one side, looking down at the blood on my hands, and not once did she look into my eyes. I made my way past her and into the flat which smelt like the windows had not been opened for days, the way a bedroom smells first thing in the morning after a long night of sleep.

'Something terrible has happened.' I carried on walking into the kitchen, turned the taps on and started to rinse the blood off my hands. Mrs Roman stood apart from me in a corner of the room, still clutching her coat, as though she was naked underneath. I was shaking, I was sweating and I felt sick

in my stomach for what I had just done. 'You have to let me stay here for a while Mrs Roman, I've lost my key and I've got nowhere else to go,' I said to her.

'What have you done?' She shook her head from side to side.

'Someone just tried to mug me and throw me into the river, they took my keys, they took everything, I'm lucky to be alive,' I said, rubbing the blood frantically from my hands.

'What's happened to you Daniel?'

'I promise you it was me or him, you don't know what it's like, you never go out, they cut your throat for the fluff in your pockets,' I said, 'I wouldn't hurt a fly, you know me Mrs Roman.'

'I've known you all your life Daniel,' she said, 'I know when you are telling your lies.'

'I had to protect myself.' I turned off the taps but my hands were still stained with blood.

'You can scrub as much as you like but you will never be able to wash off the blood of an innocent person.'

'You're not listening to me, you never listen, I'm telling you there were two of them, and they would have killed me.'

'If that were true your hands would be as clean as mine,' she brought her hands out from inside her coat so that I could see how clean they were. 'Look at my hands Daniel, look at them, they may be old and useless, but they are clean, that is how clean your own hands should be, look at them, Daniel.'

'I am looking at them,' I said, a little vexed, 'but I have nowhere else to go Mrs Roman, please let me stay here just for a day or two, they won't come looking for me here.'

'Maybe what they say about you is true,' she said, taking a step back as if I was suddenly going to hit her on the head with the first thing I could lay my hands on.

'You know me, I would never hurt a fly.'

'I don't know you at all,' she said.

'Of course you do.'

'Take this coat Daniel, it will keep you warm even along the river.' Mrs Roman's hands now lifted it from her shoulders, and that same smell of a room that had been slept in all

night long was trapped inside the coat. It was hot and moist, and it hit me as soon as she took it off.

'I'm not going back to the river,' I said to her, 'I'm never going back there again.'

'Take it Daniel, it's yours,' she held the coat out so that I would take it, but it was so heavy and she was so weak that it sunk lower and lower, I had to crouch down with my back to her so that I could feed my hands into the sleeves.

'I could help you clean up and go to the shops and brush your hair, just like I used to. Look at this place Mrs Roman, it used to be so clean, you can't do it all by yourself, you need someone to help you,' I said but I knew she had made up her mind. I turned back round to face her, wearing the long coat that had belonged to her husband, which was as big on me as it was on her.

'It's your hands you have to keep clean,' she said, and turned me around as though I couldn't see, as though we were playing a child's game of blindman's-buff, and she guided me towards the door with more strength than I thought she had.

'Just one or two days Mrs Roman, then I'll be gone, I promise you.'

The door closed behind me and I was left in the darkness of the corridor. I saw the light dissolve from the gap under her door, as though it had never been turned on.

The train station was the only place I could think of to go. The last train had left the station for the night, and the first train was yet to arrive, but the bodies of people waiting for the trains in the morning already covered the floor. There were so many of them, that you had to step carefully so that you didn't tread on anyone. Some of them lay fast asleep, with their heads resting on bags and boxes so that the thieves who lived in the station would have to lift their heads gently from the boxes before they could run off with them. I lay down in a corner by a bench that had so many planks of wood missing that it was more comfortable to lie on the floor, I looked up at the huge clock which had stopped at twenty minutes past eight and I swear I saw the hands of the clock move. They say that the broken clocks will start ticking just before the next

earthquake, they say that it will give you enough warning to run out into the street where it's safe. It seemed to move forward just a little and back just a little, so that you couldn't really tell whether it was moving at all and for a little while I almost forgot what I had done. I stared at the clock until my eyes began to close, and I went off to sleep, by a bench in a corner of the train station.

As soon as I woke up I remembered what I had done. There were people gathered all around me, and for a moment I thought that they were there for me. But they didn't even know that I was there, they were looking up at the departures board, listening out for the announcements that blared from every direction, loud and indistinct, each as difficult to understand as the next. And the men in uniform at the head of the platform were not watching out for me, but were there to keep the people without tickets away from the trains. They waved money at them and food and babies, they waved whatever they had so that the guards would let them onto the platforms, but only those with tickets were allowed through. I had never seen the station so busy, and I don't know how I could have slept through any of it. And the voice in my head kept repeating 'What have I done?' over and over, louder than any announcement and any train pulling in or going out.

I didn't last very long on my feet, I felt weak and dizzy and had to sit down again on a bench next to a girl with a brightly coloured headscarf who was surrounded by so many bags and boxes that I wondered how she would ever get them onto the train. But she wasn't on her own; her mother and father appeared from nowhere as soon as I sat down on the bench, and they all looked at me as though they knew what I had done the night before. The father was a dark man with a moustache that was almost lost in all the stubble on his face, and the mother wore the same brightly coloured headscarf as her daughter, and slippers like a genie that were half on and half off, which she dragged across the floor with her feet. As soon as I sat down, the girl stood up and her father took her place next to me on the bench because they didn't like the look of me.

I didn't last long there either. I stood up from the bench,

but there were so many people coming from all directions with bags and boxes, and my legs were so weak, and I could feel beads of sweat begin to trickle down my forehead, and everyone looked at me as though they all knew exactly what I had done the night before. Their disapproving faces began to blur as I swayed from one side to the other. I closed my eyes just for a moment and when I opened them again, I saw a woman wearing a red woollen dress with a high collar coming towards me. The announcements echoed off every wall yet none of them made any sense, people shouted at the men in uniform, begging to let them onto the trains. I closed my eyes and opened them again, and when I did, the woman with the red woollen dress was right there in front of me, and she too was looking at me like she knew what I had done, but she put her arms around me and squeezed me tight, and for a moment I thought that I had imagined it.

'Where on earth did you get to Victor? We've been looking everywhere for you,' she said, with her arms still around me and her body pressed against mine. My knees began to give way and the woman ended up taking all the weight of my body so that I wouldn't collapse onto the floor. 'Oh my God, are you all right?' she said.

I nodded my head, but I couldn't stand up straight without her help.

'Come here and sit down.' The woman put her arm around my waist and led me to the nearest wall so that I would have something to lean against other than her. I could hardly lift my feet, the soles of my shoes dragged against the floor and they split even further from the leather. I sank onto the floor with my back against the wall lower and lower, until I was sitting down with my legs stretched out ahead of me looking at the soles of my shoes which had come apart from the leather. The woman crouched down beside me, I closed my eyes and tried to breathe deeply so that I wouldn't be sick, and I felt her put her cool hand on my forehead.

'I think you've got a temperature Victor.' She put her fingers through my hair and I opened my eyes again. The woman was about sixty, she had a shiny face and wore a red woollen dress

with a high collar, that looked more like a long jumper than a dress, she had put a man's belt around her waist and that's what made the jumper into a dress.

'I was convinced that something terrible had happened to you, I can't even tell you the things that have been going through my mind,' she said.

'My name is Daniel Glick,' I said to her.

She took her hand away from my forehead as though it had suddenly become too hot, and stepped away from me so quickly that she lost her balance, and would have toppled over onto her side had she not clutched at my sleeve and regained her balance. She looked me up and down, she looked at my clothes and looked at my shoes, and looked at my face again. 'I've made a terrible mistake, I thought you were someone else.' She stood up to go, straightened the belt so that the buckle was right in the very centre of her waist, but changed her mind at the last minute and crouched down again at my side. 'What did you say your name was?'

'Daniel Glick.'

'Don't you have anywhere to go?' she asked.

'All my family died in the earthquake,' I said to her.

'Don't you have anyone?'

I shook my head.

'When did you last have something to eat?' She put her hand on my head again.

I shrugged my shoulders.

'You poor thing, no wonder you can't stay on your feet,' she said. 'You must come back with me, there's a bus that leaves from just outside the station, God knows what will happen to you if you stay here.' The woman lifted me up, put her arm around my waist and took me out of the station, away from the chaos.

We boarded a bus that was outside and waited for it to fill up. I sat down behind her on the single row of seats by the doors from which you exit, and she kept turning around to look at me. 'Unbelievable,' she said, shaking her head as she looked at me. 'My name is Agnes Russo by the way,' she said, and then turned back to face the front of the bus.

The other buses arriving at the station were packed full of people with bags and boxes, and yet our bus was filling up so slowly, as though people were getting on the trains that were leaving the city but no one was getting off the ones arriving, in the end the driver just closed the doors and the bus started moving long before it had filled up.

We got off the bus on a road at the edge of the city centre that was wide and busy and almost like a highway. There were no houses and no shops and no people on the street, and all the other passengers stared at us as the bus pulled away, as though we didn't really know where we were going and had got off at the wrong stop.

We crossed the building site of the new parliament complex that will be so big and so grand that they had to pull down streets of houses to make way for it. They had to pull down the building in which Marina had lived, the whole street that it was on, and all the other buildings and the streets around it. The path that we took led us into a part of the city that I had never been to before; there were old houses lying derelict because they were waiting for the bulldozers to tear them down, and the pavement was crooked and uneven and you had to take care that you didn't trip over and fall.

'We're almost there now.' As soon as she spoke those words everything around us changed; I saw houses that weren't empty and derelict, there were cars parked outside and children playing in the street, just like in any other part of the city. Except that it didn't feel like any other part of the city, it felt as though we had wandered into another village in another country, like in a children's story where they stray too far into the forest and end up in a strange land that is different from anywhere else, and even if everyone in the city was looking for me, they would never think to look for me there, I thought to myself.

The woman lived in a block of flats that looked just like mine. We climbed flights of stairs until there were no more stairs left to climb, and when she knocked on the door to her flat, a tall man with grey hair and a lazy eye opened the door immediately, as if he had been expecting us.

'Edgar, I want you to meet Daniel Glick.' Agnes Russo stood behind me and put her hands on my shoulders.

'Daniel Glick?' The man with grey hair opened his eyes wide in surprise, they darted from me to her and back again, but you could still tell which was the lazy eye and which was the normal one.

'You heard,' she said, 'Daniel Glick. This is my husband Edgar.'

'I'm very pleased to meet you,' I said.

He opened both eyes in surprise even further so that this time you couldn't tell which was the lazy eye any more, the look of surprise remained fixed on his face, as though the wind had changed direction and the expression had become stuck there for ever, like people are always warning it might.

'Who does he remind you of?' said Agnes Russo.

The man with grey hair was shaking his head without saying a word.

'He was about to collapse from hunger when I saw him.' She started pushing me gently into the flat.

'Unbelievable,' he said, still shaking his head.

'That's exactly what I said.'

'You are very welcome in our house Daniel.' The man finally stopped staring at me, he held out his hand for me to shake. Edgar Russo was tall and thin and as pale as death, he had little lines around his eyes from too much smiling, they stretched in all directions from the corners of his eyes, and they made him look like he was smiling even when he wasn't.

'Take off your coat, make yourself comfortable.' Mrs Russo started pulling at the coat that Mrs Roman had given me the night before, and I undid the buttons at the front and stretched my arms out behind me, and when it came off she handed it to her husband who hung it from a hook above a row of shoes and slippers by the door, just like the one in Mr and Mrs Roman's house.

Mr Russo led me into the living room and insisted that I sat on a layer of as many cushions as the room could spare, pulling them away from all the corners where they lay. He arranged

the cushions on the sofa and I sat uncomfortably on top of them, leaning to one side so that I wouldn't topple over, my feet dangling off the end, like a child in a barber's shop having his hair cut.

The room was small and cluttered, there was a dining table with four chairs, the tops of which were so ornately carved that they looked like thrones, and a cabinet against the wall that was crowded with ceramic dolls, little figurines, plastic flowers and fruit, just like the cabinet in Mr and Mrs Roman's house, the one that Marina had so shamelessly coveted. So many things about them reminded me of Mr and Mrs Roman that I already felt that I knew them, and for once I couldn't believe my own luck.

Mr Russo sat down on one of the chairs at the dining table that looked like a throne, and surveyed me from top to bottom. 'You've got gaping holes in your shoes, Daniel Glick,' he said, 'they look like they could hold a conversation of their own.' We both looked down at my shoes and he was right, the soles had come away from the leather so much that they looked like the wide open mouths of the fish in the market. Suddenly an idea came into his head and his face brightened, 'You can get rid of those old shoes, I've got a pair that you could wear, and I bet you they fit perfectly, I bet you anything you like.' He stood up from his chair, his knees cracked as he did, and when he left the room, he walked with his back bent forward, as though he had been sitting down for hours. When he came back into the room he had a shoe on each hand as though they were gloves. 'Promise me that if the shoes fit you'll wear them,' he said.

'I promise,' I said, but Mr Russo was so much taller than me, and his feet looked so much bigger than mine, that I really didn't think that his shoes could ever fit me. I couldn't even reach down to put them on because I was perched so high up on all the cushions.

'You must let me do it for you,' he said. He bent down slowly in front of me, and I heard his knees crack again, he untied the laces of one of my shoes in the way that a spoilt child tears through wrapping paper on Christmas day. He

tossed my old shoe away and put the other one on, tying the laces tight. 'How does it feel?' he asked.

'It fits well.'

'Don't sound so surprised,' he said.

'Are they yours?' I asked.

'I told you so Daniel, I knew it would fit you,' he said, ignoring my question. 'Come here Agnes have a look at this,' he called out.

Mrs Russo came running into the room as though it was on fire, and Mr Russo held up my foot to show her. She squeezed her eyes in delight.

'Look at it Agnes, it fits him perfectly,' he said to her.

'Well I must say, I'm not surprised one little bit.' She ran out of the room as quickly as she had run into it, as though the kitchen was now on fire, and I was the only one who was surprised because the man's feet were so much bigger than mine.

He took hold of my other foot and put the other shoe on it, and once he had finished tying the laces he stood up holding onto the furniture around him, his elbows and his knees cracking all the way. He put out his hand to help me to my feet. 'Now walk around and see if they feel comfortable.'

The room was so cramped that there was really nowhere for me to walk, so I walked on the spot in front of the sofa, my arms swinging by my side, like a soldier on parade, and I must admit that the shoes did fit well; even the little dents inside the shoe that are made by your toes seemed to match the shape of my own, as though the little dents had been moulded by my toes and not by his.

'They're yours to keep,' said Mr Russo, and I stopped marching on the spot.

Mrs Russo came into the room with a bowl of soup and put it down on the table. 'Did you ever see such a perfect fit?' he said to his wife.

'If only they were edible he'd have all his problems solved, now leave him be Edgar, he's going to collapse in a minute if he doesn't eat something.'

The soup was so hot that I couldn't even touch the spoon which was lying in the bowl, half in the soup and half out.

Mrs Russo came back into the room with a glass of milk and a yellow apple on a little plate, which she placed on the table.

'Don't you like the soup?' she asked.

'It's too hot to eat yet,' said Mr Russo, and he put his head right next to the bowl and started blowing onto the soup, and Mrs Russo did exactly the same thing, each one puffing harder than the other, as though they were blowing out the candles on a birthday cake for a child too young to do it by himself.

'Now try it,' she said, as she pulled her husband away from the bowl of soup.

I put a hot spoonful in my mouth.

'It's delicious.' I said to her, and her face lit up.

'Come Edgar, let him eat in peace.' She took her husband out of the room into the corridor, and they left the door open, so that they could watch me eat the soup. I could hear them whispering halfway down the corridor, but I couldn't make out what they were saying. Every time I looked back at them they seemed to get closer and closer, but not once did I see them move. In the end they were so close that they were practically inside the room again. 'There's more if you'd like some,' said Mrs Russo, the moment that I'd brought the last spoonful of soup up to my mouth.

'This is fine.'

They both came towards the table and this time I did see them move. Mrs Russo took the spoon from my hand before I had a chance to put it back down in the bowl, and with the other hand she took the bowl from the table, and went into the kitchen.

'Agnes and I have been thinking that we'd like you to stay with us here in the flat.' He put his hand on my shoulder.

'We couldn't let you go back to sleep rough in that awful station. What about your family, where do they live?' he asked.

'All my family died in the earthquake,' I told him.

'All of them?' I nodded my head.

Mr Russo patted me on the back 'You can stay here as long as you like, Daniel,' he said.

'It's no trouble for us,' said Mrs Russo, as she started to peel the yellow apple on the plate on the table. 'We've got no children of our own, and there's a spare room that you can sleep in.'

'Thank you,' I said.

Mrs Russo finished peeling the apple, and then she cut it into little pieces. Her husband took his hand off my shoulder and pushed the glass of milk forward on the table so that it was right in front of me, and so that I wouldn't have to stretch out for it even just a little bit. Mrs Russo collected the apple peel from the table and then they both left the room and stood at the end of the corridor where they had been standing before, and by the time I finished the apple they were in the same room again, but not once had I seen them take a step towards me.

The room that Mrs Russo had prepared for me was small and cramped, just like the rest of the flat. It made me think of Marina's old room; it had a small bed, a wardrobe and a basin in the corner, there was little room for anything else. Mrs Russo pointed out the bed, the wardrobe, the basin and the windows. She took some old coat hangers out from the wardrobe and said that I should hang my clothes by the window so that they would air. They wished me goodnight in whispers, as though I was already asleep.

I hung my clothes from the hangers on the curtain rail above the window, just like Mrs Russo had showed me, and pissed into the basin in the corner of the room.

Mr and Mrs Russo's flat creaked all night long, the way all old buildings do, the way old people do when they get up from an old sunken armchair. But the mattress was almost new and the sheets were clean and I was so tired that I fell asleep listening to the creaks. My clothes hung from wire hangers on the curtain rail above the open window, they floated in the current of air which came in through the window, like the ghost of the village idiot seeking revenge in the night, but I was so tired that even that didn't stop me from falling asleep.

Six

The day that I tried to run away to the circus I was back home that same evening, I was fast asleep in my own bed before the clowns had time to wash the smiles off their faces, and the adventure came to an end before it had even begun.

But not even the clowns could rouse me from my sorrow that day, no matter how many times they stumbled and fumbled and came crashing to the ground, they could do nothing for me because my mother and father had left the country and I would never see them again. They had disappeared from one day to the next without even saying goodbye, without telling me where they were going or when they were coming back for me, and I was inconsolable. That's the reason I decided to run away.

The week after my parents left, my grandfather received a letter from the headmaster suggesting that I should be sent to another school. He went to have a look at it, and when he got home that night, he said that it was a special place for children with no parents, and that was why they had suggested it for me, the children there wore their pyjamas both night and day, and they had their hair cut short so that lice wouldn't spread from one child to the next. He said that he would rather I joined the circus. Those were his words, and that's what gave me the idea.

I had just turned twelve and Mrs Roman took me to the circus partly as a birthday treat and partly to cheer me up. It was the very last night of the season and I wore as many of my clothes as I could fit into so that I could accompany them to the next town. It must have been obvious that I was planning to run away because Mrs Roman held my hand very tightly the whole night. Not until the very end of the performance did she release it, and by that time it was so numb that it was hardly good for anything.

All night I waited for the right moment. With the one hand that was free, I wiped the beads of sweat that poured down my

face because of all the layers of clothes that I was wearing, but I would never be able to run for it as long as Mrs Roman gripped my other hand so fiercely.

We saw the clowns and the bears and the girls on ponies and the dogs that jumped through hoops, then for the finale there was the flying trapeze. Everyone applauded because they had finished their act, except for me and Mrs Roman that is. Usually at that point, all the other performers come into the ring and they sing the circus song and then it's all over, but that night the music stopped and the ringmaster came on and he waited until everybody had finished clapping before he spoke. He was wearing white face powder just like one of the clowns, and a long coat of many colours that sparkled in the light as he spoke.

'As you know ladies and gentleman tonight is our very last night.' The audience gave a large sigh that went on for so long, that the ringmaster put out his hands to quieten everybody so that he could continue. 'As it's the last night, we want to leave you with something special that we hope you will never forget. You have just seen the Great Renaldo, our international star of the high wire perform his act, an act already known throughout the world for its daring, but tonight ladies and gentlemen, as a parting gesture he will again perform his last somersault but this time with only one hand and,' he paused for ages, 'without a net.'

A spotlight dashed across the ring and settled on the Great Renaldo himself, who had already descended the ladder, and was waiting for something at the bottom. He gripped the ladder with one hand and he held out the other to receive the rapturous applause of the public. 'And to prove it to you, ladies and gentlemen, he will take a bouquet of the most delicate and rare flowers in the world and hold them in his left hand, and you will see that not one of these precious gems of the natural world will fall to the ground.'

At that moment another spotlight fell on the back of the ring and one of the girls who had performed at the beginning came out standing on her pony which was being pulled by a dwarf who had earlier cavorted with the clowns. The girl's

arms were outstretched to maintain her balance, and in one of her hands she held the delicate and rare flowers of which the ringmaster had just been speaking. Again the audience clapped.

The dwarf pulled the pony all the way to where the Great Renaldo was standing, and the girl handed him the bouquet of flowers. Renaldo bowed down to the girl and gave her a kiss on each cheek, then he scrambled a few steps down the ladder and gave the pony a kiss on each cheek, at which point everybody laughed and clapped. Then he paused and looked at the dwarf and with his finger beckoned him over so that he could kiss the dwarf on the cheeks as well. The dwarf leant away from him as far as his little back would extend, and he shook his head from side to side, and pulled a face like he had to eat a vegetable that he didn't like, then he began to run off in the other direction, and everybody laughed even more. He came back to pull the pony away and they returned to where they had both come from, waving to the appreciative audience. The Great Renaldo put the bouquet in a little belt around his waist and began to climb the ladder as the spotlight followed him all the way to the top.

'You will see for yourselves tonight ladies and gentlemen that the Great Renaldo will value those rare and precious flowers more than he values his own life,' said the ringmaster.

Once he reached the top, the drums began to beat so heavily that you could feel them inside your own heart. Another man swung from the other trapeze waiting to catch Renaldo after he somersaulted in midair, but Renaldo wouldn't start until the timing was perfect. People from the circus gathered at the bottom, as though they were expecting his fall. Backwards and forwards they swung, the drums rolled, the moment came, Renaldo gave the sign and then launched himself into the air. He did one somersault and then another, and as he put out his hand to be caught by the other man, it looked like he wasn't going to make it, Mrs Roman let out a scream and released my hand so that she could cover her mouth, but at the very last moment Renaldo was miraculously caught by the man on the other trapeze, and everybody could breathe once more. And not one flower from the bouquet was dropped.

Mrs Roman had brought her hand up to her mouth so quickly to cover it that she accidentally cut her own lip with her wedding ring. Everyone under the tent clapped and cheered as the Great Renaldo began to pluck the little flowers from the bouquet and throw them into the air; the flowers descended gently, one after the other, and everyone tried to catch them as they swirled to the ground. Mrs Roman continued to cover her mouth, and you could already see that there was blood trickling through her fingers. She stood up from her seat and everybody thought that she was standing in appreciation for what she had seen, and it was because of her that the Great Renaldo got a standing ovation, but all Mrs Roman wanted to do was to find a little corner where she could spit out all that blood. The music blared from inside the tent as the band played the circus song for the last time that season, and it seemed that this was the perfect moment for me to make a run for it. But poor old Mrs Roman was spitting and coughing so much that it sounded like she was going to vomit the entire contents of her stomach right there in the circus tent, and I just couldn't bring myself to leave her. She spat all the way home until there was no more blood in her saliva, and I never got to run away to the circus, or anywhere else.

My grandfather was waiting for me when I reached home, he embraced me so hard when I walked through the door that I didn't know whether he was pleased to see me, or whether he was trying to crush me to death.

'Mrs Roman cut her lip at the circus and we had to come home before the end,' I said to him.

He let go and pushed me away from him. 'It must be cold at the circus, that you have to wrap up so warm.'

The sweat was pouring down my face and I didn't know what to say to that. He took off my jacket and carried on taking layer after layer until I was down to my underwear. I held my arms up in the air so that the layers would come off more comfortably, and my grandfather counted each one as he peeled them away, there were seven layers in total. He opened the door and went into the bathroom which we shared with

the other neighbours, and I heard him run the bath for me. By the time the bathtub was full I was beginning to feel the cold. I walked from our flat into the bathroom, dragged my underwear down to my feet and stepped out of them, my grandfather sat on a chair in the corner watching me as I got into the bath.

'You can't run away to the circus just because you miss your mother and father,' he said. 'Now that your father is no longer around you've become the master of this house.' He pointed down towards the floor as he spoke.

'What if I decided to run away to the circus because I missed them? Don't you think I miss my own son?'

'But you're too old to be in the circus, and I'm still too young to be the master of this house.' My words echoed around the walls of the bathroom which were sweating from the steam that rose from the water in which I sat.

'How old are you now?'

'Too young,' I said.

'How old?'

'You know how old I am, I just turned twelve.'

He shook his head. 'You can't tell me you're too young when you're naked in the bath Daniel, when I can see the hairs on your legs and on your balls. Nobody can lie when they're naked.' I looked at my legs and my balls and at the hairs that grew there as they swirled under the water. 'Do you really want to live the rest of your life with monkeys dressed as men and dogs dressed as women, and end up married to a lady with a beard and have dwarves for children?' I was still looking at the hairs on my legs.

'I've never even seen a dog dressed up as a woman,' I said.

'Do you really want to clean up horseshit all day long, and live in a caravan like gypsies?'

'They're not all gypsies in the circus.'

'The people in the circus are dirty gypsies and their lives are cursed from start to finish, everybody knows that Daniel,' he said.

Still I was fascinated with the hairs on my body that seemed to have appeared there overnight. 'How come we get hairs on

our legs but not on our feet, and under our arms but not on our shoulders?' I asked him.

My grandfather put his hands on his knees and lifted his trousers so that I could see the scattered hairs on his pale legs. 'It's so that you know where to rub the soap when you wash yourself,' he said that so I would hurry up in the bath. He stood up to show me where to rub the soap to wash myself properly. 'You only need to soap yourself in the places where you have hair.' He raised one arm after the other high up in the air, higher than was necessary, and pretended to rub soap under each one, he lifted one leg and pretended to rub soap on it in the same way, until he lost his balance and tried again with the other, and then he pretended to rub the soap in between his legs, at the front and at the back. 'You rub it here, and here, and here, and here,' he said.

I pointed to my head because my grandfather had forgotten that there was hair on his head and that you had to soap that hair as well, even though his was getting thinner and whiter every day, but instead of pretending to rub soap there, he continued to rub it in-between his legs at the front and at the back. I kept pointing at my head and he kept rubbing his bottom, all without saying a word, like the animals in cartoons that point at things because they can't speak, and it made me laugh for the first time since my mother and father had left.

'And if you have hair all over your body like the monkey man or the bearded lady, that's because you're dirty all over and that's why the circus is full of dirty people and that's why you are banned from going there ever again.'

'You can't do that,' I said.

'I can do what I like.'

'How can I be the master of the house if I can't even go to the circus when I want to?' He went to smack me on the head, but his hand slowed down in midair and it was more like a caress.

'Maybe with a chaperone then,' he said.

'Not Mrs Roman,' I said, 'she can't handle it.'

'Don't expect me to take you to see those gypsies,' he said. I stood up in the bath and started to soap myself in the

places where I had hair, like I had just been shown, but I dropped the soap into the bath. It moved under the water like a fish in a tank, and slipped through my fingers when I tried to take hold of it. My grandfather put his hand in the bath and took hold of the soap, he rubbed it under my arms and between my legs at the front and at the back, just like he had done on himself. I struggled and pleaded with him because it tickled so much, and I laughed so much that I forgot that I had been so miserable. Then I submerged my whole body under the water to rinse off and the water turned grey, almost white, so that I could no longer see any of the hairs that grew on my legs or under my arms or on my balls.

My grandfather held a towel out for me so that I could dry myself. He wrapped the towel around me as though I was a Roman emperor and made a little trumpet sound out of the corner of his mouth. But the plughole in the bath was gurgling and coughing as it drank the grey, almost white water in which I had just been sitting, choking on it because it drank so much so quickly, and it drowned out the little trumpet sound that my grandfather was making out of the corner of his mouth. He picked up my underwear from the floor and put it on my head as if I was being crowned emperor and I walked back into the house triumphantly as though that day I had really become the master of the house. My grandfather ran into his room and came back with the key that had belonged to my father and he handed it to me.

A week later Mr and Mrs Roman brought me a puppy in a box, so that I wouldn't miss my parents so much, and I did become the master of the dog even if I wasn't really the master of the house.

Mr and Mrs Russo's flat was more quiet in the day than it was at night; there was no television in the cabinet, no cars out on the street and no neighbours above or below. I was woken by a ray of sunlight that came in through the window like a torch shining in the night, I saw its orange glow long before I opened my eyes. Dust floated in the ray of light as though it was present only in that beam and not in the rest of the room

and not during any other time. Nobody would ever find me here in this place I thought to myself as I watched the dust floating peacefully in the sunlight. Not in a million years.

My clothes were still gently swinging from the curtain rail above the window, they were stiff and dry like the flannels Marina used to hang in the kitchen, I took them down from the hangers and put them on.

There was nobody in the flat but me. I looked through the shelves of the cabinet in the living room crammed with vases and dolls and ceramic princesses, peasant girls caught in the act of walking or washing their feet, flowers made of cloth, fruit made of plastic and elephants made of wood. It contained exactly the same things as Mrs Roman's cabinet, the one that Marina had coveted so shamelessly.

Leaning against the back of the cabinet, behind the oriental princess perched high on her pedestal, and the plastic fruit that looked real enough to eat, was an old photograph of two babies dressed in white gowns. I put my hand in amongst the clutter of fragile objects in the cabinet and reached for it. One of the babies was Mr Russo, there was already something of the old man in his face. His eyes were big and brown and wide open, and they stared excitedly at something that was happening just above the camera, as if it was the most extraordinary thing in the world. His little arms were suspended in midair for no reason, elbows bent, the way that dolls have their arms arranged by their sides to make it look as if they're in motion, and his fingers were spread out from all the excitement. The baby next to him could have been a boy or could have been a girl; it was smaller and younger and looked like it was about to topple over at any moment, except that it was held in place by the other larger baby, and whatever it was they were sitting on. It was also staring excitedly, desperately trying to locate the extraordinary thing that was taking place somewhere in that room, but he or she didn't find it in time. On the back of the photograph was a date in Roman numerals and a few words written in ink that had long since faded into senselessness.

Mr Russo cleared his throat behind me, in the way that people do when they want to announce that they have entered

the room. I threw the photograph back amongst the fragile figurines so that he wouldn't catch me looking at his things, but the oriental princess who stood so delicately on her pedestal, got in the way of the photograph, she rocked from side to side before finally toppling over, and without any effort whatsoever she had broken her little neck on the side of the cabinet. Her head came away from her shoulders like the head of a French aristocrat, and it rolled towards the peasant girl who was still washing her feet in an overflowing pail of water.

But Mr Russo hadn't walked into the room at all. The coughing was coming from the bathroom and it was getting louder and louder. I heard him gasp for breath after each one, as if he had emptied his lungs of all the air inside, just like Mr Roman before he died.

'Are you all right in there Mr Russo?' I put my ear to the door and suddenly the coughing stopped. 'Is there anything I can do?' I pushed the door open and saw Mr Russo slumped on the floor, his head resting on the side of the bathtub and his arms dangling over it, like a seasick sailor leaning overboard. There were specks of blood inside the white bath, on his thin pale arms and all over his white vest as though he had just been beaten up, his legs were stretched out on the floor and they prevented me from opening the door all the way. 'What happened?' I pushed hard against his legs with the door so that I could enter the bathroom.

Mr Russo turned his face away from me. 'Nothing happened.' He cleared his throat before and after speaking, as if they were the only words he had uttered all morning, but still his voice sounded hoarse and deeper than I remembered it from the day before. 'This is what there is,' he said, 'and there's no remedy for it.' He hurried his words to make way for a sound that was half cough and half sneeze, and more spots of blood appeared on the bath in an instant. 'Better out than in, that's what the doctor says,' he said. 'Agnes is usually here to help, I don't know what's keeping her today.' He looked up at me for the first time since I had gone into the bathroom.

'You're lucky to have such a devoted wife,' I said to him.

'And she's unlucky to have such an invalid for a husband.' He swung his arm slowly from inside the bath towards me, like the movement of one of the gigantic cranes that tower over the building site of the new parliament. 'Help me sit up if you can.'

I got behind him and put my arms under his, and as I lifted him onto the seat of the toilet, his trousers fell to his knees and he grabbed them with one hand so that they wouldn't fall all the way down to his ankles.

'Who will take care of Agnes if she gets sick? I certainly won't be around to look after her, who's going to look after you when you get old, did you ever stop to think of that?' His eyes began to water and his whole body tensed up to suppress another cough that couldn't be contained any longer. Again he made a sound that was half cough half sneeze, and even though he put his hand over his mouth just in time, it didn't stop him sending a spray of blood onto the tiled wall and the mirror that hung above the basin, which was already marked with little dark spots because it was so old, like the dark spots on Mr Russo's hands, which were there for the same reason. He stood up and looked at his face in the mirror. 'Look at what I've done to your clothes.' He stepped away from the mirror so that I could see my reflection. My shirt was speckled with his blood as though that was the original pattern on the material. 'Agnes will have a fit if she sees that.'

'Don't worry about these,' I said, 'they're old clothes anyway.' I started wiping the mirror clean of his blood with a rag that was on the side, smearing it in and making it worse before making it better.

'I knew you were a kind person the moment I laid eyes on you,' he said talking to my reflection in the mirror that I was cleaning.

'It was you who took a stranger into your house,' I said.

'That's the thing Daniel, you're not really a stranger to us,' he shook his head, suddenly he was animated again, 'we both feel we know you already.'

'I could have been anyone, I could have been a murderer for all you know.'

'But you're not anyone, you're not a stranger to us at all,'

he said, 'and I bet you that we're not really strangers to you either, I bet you anything you like.'

The mirror was now clean apart from the black spots which were marks from the inside, and which could never be removed. I turned towards the bath and opened the taps as far as they would go, and rinsed the rag of all the blood it had collected.

'We know everything about you Daniel, even though we only met you yesterday.' He continued to speak through the whistling of the taps, and I was only half listening because it seemed to me that he wasn't making much sense at all, just like Mr Roman when he became sick.

The front door opened and then slammed shut. Mrs Russo let out a little cry because the draught had seized the door away from her hands and slammed it hard behind her as she entered. The noise of the door slamming echoed so loudly throughout the building that it sounded like there was another door being shut on another floor, in the same building, in the same way.

'There's hardly a soul out on the streets today, and most of the shops aren't even open,' Mrs Russo called out to whoever was listening, but her husband didn't respond. He was too busy keeping the door of the bathroom closed with one hand and holding out the palm of his other hand in front of me, so that I wouldn't move or make a sound. 'You couldn't even feed a dog with the things they had in the shops.' We heard her drop the plastic bags. 'You don't know how much trouble I've been through just for this crap.'

She started opening and closing the doors of the flat, looking for her husband. All the time she didn't stop talking, calling out to whoever was listening, mumbling to herself about how there were no people on the streets, and about how the shops weren't open, and about how she had to resort to buying things from the old women who come in from the countryside and gather in the squares to sell the things that grow in their gardens, and how even those things had been expensive that day.

Finally she tried the door of the bathroom. 'Edgar, there's nobody out in the streets today.' Mrs Russo tried to push the

door open as she spoke, whilst on the other side her husband was pushing to keep it shut. 'What are you up to in there?'

'I know,' he said, 'I heard you the first time.'

'Well then why didn't you say anything?'

'What am I supposed to say to that?' he said.

'And where's Daniel got to, don't tell me you let him . . .'

He didn't let her finish. 'He's here with me, I've just run a bath for him.'

'Well, kindly inform him that we'll be eating like peasants in this house today because the shops are full of crap,' she said, a little bothered that no one was taking any notice of her, then she was gone.

'Did you hear that Daniel? Peasant food for us today.'

'Better that than nothing at all.' I told him.

'Consider yourself informed,' he smiled.

Mrs Russo again came to the bathroom door. 'And did you see the china doll is broken again?'

Mr Russo stopped what he was doing and looked straight at me. 'I'll stick it back together,' he called back, 'as soon as I finish in here.' Mr Russo was losing patience with his wife.

'It's bad luck to stick it back together a second time.'

'Then put it in the rubbish,' he said, 'it won't bring anyone bad luck in there.' That made his wife go away.

Mr Russo looked right at me. 'I told you so Daniel, history is repeating itself, everything is happening the way it happened before.'

'What are you talking about?' I said.

'That china doll that you broke, it broke once before in the same way.'

'I didn't even touch it,' I said.

'I don't care about the stupid china doll Daniel, or any of the rubbish on those shelves, all I'm saying is that everything is unfolding exactly as it did before.'

Mr Russo waited until the house was still again and until Agnes was quiet, he opened the bathroom door and we crept out on the tips of our toes to the room where I was staying.

'What are you up to now?' Mrs Russo knocked on the door, still bothered and a little suspicious that she was on her own.

'We're putting a new outfit together for Daniel.'

'Well I hope you're not dressing for dinner, because we'll be eating like peasants,' she said for the twentieth time.

Mr Russo turned the key, and the doors of the wardrobe opened of their own accord because there were so many clothes inside, the things that nobody wanted, the things that had gone out of style. Mr Russo took out a pair of trousers and a shirt that shared the same wooden hanger, they didn't look as old and unwanted as all the other clothes in the wardrobe; the trousers were grey and the shirt was green and they fitted me so well that Mr Russo said that Agnes wouldn't have to adjust them. 'Look at them, they're perfect,' he said, as he looked me up and down.

For himself he found an old jacket, which he put on over his bare chest, and a hat on his head which had lost its shape, that would not have looked out of place on a scarecrow. He put his arm around me and opened the door, we stepped outside into the living room where Mrs Russo was sweeping.

'Let peasants eat the food that is for peasants, we're dressed like kings and we will eat like kings.' He announced this to his wife in a very loud voice, with his other arm outstretched, as though he was making a declaration to a crowd of people.

'What have you got on Edgar?' she said, 'you look more like a clown than a king.'

'Today we will feast like kings.'

'If you'd been listening to me, you'd know that half the shops aren't even open today, I've only managed to get a few things,' she said looking her husband up and down.

'Then we'll go out for lunch,' he said.

'Go out where? Everywhere is closed.'

'Daniel, would you like to eat like a king?' He pressed tightly around my shoulders. 'Or like a peasant?'

'Are you drunk or something?' His wife protested.

'It's Daniel I'm asking the question to.' He pointed his finger at her as a little warning that she should stay quiet.

'But if Mrs Russo says that nowhere is open.'

'Don't be worrying yourself about Mrs Russo,' he said, 'I know everywhere there is to know in this city, and I promise

you that I'll take you both to a place where you'll eat so well that you'll be talking about it until the day you die.'

'What place do you know? We never go anywhere.' Mrs Russo put her hands on her hips.

'There are lots of things you don't know about me.'

'Now he tells me after thirty years of marriage,' she looked straight at me.

I felt safe in their flat because no one would ever find me there, and I didn't ever want to leave, but I had no choice because I was the guest and he was my host, and if he said that we had to go out to eat, that's exactly what we had to do.

Mrs Russo shook her head and a little smile appeared on her face because her husband was wearing a jacket, no shirt, and a hat that had lost its shape. 'I think you are drunk,' she said. But she had as little choice in the matter as I did, because Mr Russo was so unwell, and he was coughing blood all day long, and that's why he looked as pale as if he's died five minutes before. Just like Mrs Roman when her husband was dying, she couldn't deny him a single thing, she would give in to all his whims, all the little things that got into his head, as crazy as they may have seemed.

Seven

All three of us were supposed to leave the country together; my mother, my father and I. It was the night of my twelfth birthday, my mother had cooked a special meal and Mrs Roman had baked a cake. We had finished the meal, blown out the candles and made a wish, then Mr and Mrs Roman had left to go back up to their own flat, and as soon as they left the atmosphere changed. My mother went into the other room to turn the volume on the television as high as it would go, even though no one was watching it, she sat back down at the table and my father announced it to me in whispers. He said that we were all going together in the back of a truck that was transporting meat to another country, any old country. It was a special truck that had a freezer section in the back so that the meat wouldn't spoil in the heat. They would never think to look in there he said. It was so cold inside the truck that we would have to wear all our clothing to stay warm, as many layers as we had, other than that we couldn't take anything.

But I could hardly hear what my father was saying because the news was blasting from the other room and he had to talk over it the whole time. I asked him to show me where we were going on the atlas, but he said that it hadn't even been decided, he said the main thing was to get across the border and then we could go wherever we liked; I watched his mouth as it formed the words and I watched every blink of his eyes, and I'm certain that's what he said.

Then it was my mother's turn to whisper into my ear; she told me that my grandfather couldn't come with us. She took his hand in her own as she spoke, and he seemed to know exactly what she was saying even though her voice never rose above that of the newsreader on the television in the other room, who kept distracting me the whole time with all his bad news.

'I'm too old to start up all over again in some other place.'

My grandfather spoke in a normal speaking voice, as though the same rules didn't apply to him just because he was staying behind, and that night his normal speaking voice sounded like he was shouting at the top of his voice because everyone else was speaking in whispers.

'Promise me you won't say anything about this Dan,' said my father.

'I promise I won't.'

'Not even to Mrs Roman,' my mother added.

'Not even to Mrs Roman,' I repeated.

'I bet you he'll tell her.' My grandfather pointed at me, even though I had hardly said a word all night, even though I hadn't moved from the table, and even though it was my birthday. 'He tells them everything, all they have to do is wave a biscuit in front of him and he'll give them a full confession.'

'Don't listen to him Daniel, of course you can keep a secret, we wouldn't have told you if we didn't think you could keep a secret, you're not a child any more, you're twelve years old. Just act normally in front of other people as if everything was the same.' My mother let go of my grandfather's hand and took mine instead.

'I know how to keep a secret,' I whispered.

'Just act normally with everybody you meet,' she said.

But they had already made me so nervous about it that I thought to myself there and then that the best way to keep a secret was to say nothing at all, to keep silent and say nothing about anything to anyone. 'I won't speak until we're out of the country.'

'I knew you shouldn't have told him.' My grandfather sat back and looked around the room.

'Just act like you didn't know anything, Daniel,' said my mother.

'Everybody is leaving this country, only the old people and the fools will be left behind to run this place.' Even my grandfather lowered his voice to say that.

'It's already run by fools.' My father nodded at his own words, and everyone else did the same.

'You have to be nice to your grandfather because we'll all miss him once we've gone,' said my mother.

And I don't know why I was supposed to be nice to my grandfather when he'd been so nasty to me, saying that I couldn't keep a secret, when he was the one who was speaking at the top of his voice so that all the neighbours could hear, and when I was the one who had hardly said a word all night.

My father lit a cigarette and remained at the table whispering to my grandfather about the fools who were running the country, the cigarette smoke came out with his words and he waved the smoke away as soon as he exhaled it, as if he was anxious that the smoke shouldn't carry the words away to the neighbours.

My mother and I left the table and sat in the armchair in the other room, as the man on the television watched our every move and talked over us so that we could hardly speak. 'Don't be angry with him Daniel, he doesn't mean it, he's just sad because he's too old to come along with us.' Her face was very close to mine and she was putting words directly into my ear, so that they wouldn't get drowned out by the television.

'Cross my heart and hope to die,' I said as I crossed my heart.

But not even my parents seemed themselves after that night, everybody was nervous and distracted and whispered about everything, even the things that you were allowed to say out loud. I stopped talking altogether, just to be on the safe side, and at first nobody seemed to notice. I kept myself to myself, my head buried in the atlas, studying all the countries that bordered our own, wondering in which one of them we would end up. My mother reminded me that not saying anything at all was just as bad as saying something, and I had to behave as though nothing had changed. But I had always liked looking at the atlas and dreaming about visiting other places, there was nothing unusual about that; I fingered the marks on the page that denoted town and city and mountain and river, and thought to myself that maybe this mark on this page, which my finger was touching, was where my mother, my father and I were going. I fingered the marks so often and for so long, that I almost erased them from the page, the way that

the numbers on the buttons in the lift are erased because they are pressed so often.

But in order to cross the border in the back of a truck with the carcasses of dead animals, my parents had to save a lot of money, even more than for a ticket on a bus or on a train, even more than for first class or an aeroplane. My father was a dentist and my mother taught geography at the school that I went to, and they had to save for months so that they had the money to pay the truck driver.

There were two geography teachers at our school. My mother taught the older children and there was another woman who taught the younger children, her name was Mrs Muranda and nobody at the school liked her. She was a little older than my mother and wore glasses that were so thick that it made her eyes look bigger than everybody else's, and her teeth stuck out so far from her mouth that she could hardly keep it closed, even when she wasn't talking. But all her nicknames were about her glasses, even my mother used those names when she talked about her at home.

Everybody knew that she only got the job because her husband was high up in the police and he arranged for her to work there. He could arrange anything. She made mistakes all the time because my mother told me that she did, sometimes even I could tell that she made mistakes, but I had been warned never to correct her. My mother had taught me about every mountain range and every river in the country, and I knew all the capitals of the world off by heart before I had even started at that school.

We were doing things in class that I already knew about. We had to draw the rivers of the country and their main tributaries over and over again, we did it so many times that the lead in our pencils would run out or even break. Mrs Muranda had the only pencil sharpener in the whole class so we had to put up our hands if we wanted to use it. She'd call us to the front of the class, and before sharpening the pencil, she examined the lead to see if it was worn out or if it had been broken. Sometimes the lead broke of its own accord, but she'd blame us, as though we'd done it on purpose. That day

my lead broke three times and I had to go up to the front of the class three times, on the third occasion Mrs Muranda examined the pencil closely and saw that the lead was broken. The lenses on her glasses magnified her eyes so that I could see every little detail, the black spot that was her pupil, and the thick blue line that she had drawn underneath her eyes to make her eyes look even bigger than they already were. She took hold of my ear and twisted it in front of the whole class. 'If you used it properly, the lead wouldn't keep breaking.' She threw the pencil across the room, it bounced off the wall and then off the metallic legs of the chairs on which the other children were sitting. 'Maybe your mother should teach you to use your right hand instead of your left.' Finally she let go of my ear. 'Now sit down,' she said.

I had hardly spoken a word since my parents told me that we were leaving the country, and everything came out that day in front of Mrs Muranda, and in front of the whole class. 'I don't need to draw your stupid maps anyway, I know about all the rivers better than you do.'

'Sit down Daniel,' she said again.

'I know all the stupid mistakes you make, you only got the job because of your husband,' I said to her, and once I had started I couldn't stop myself. 'Anyway you won't be seeing me for much longer because we're all leaving the country and I'm going to have as many pencils as I like and a sharpener all of my own.' I called her one of the names that we had for her in front of the whole class, and then I sat back down at my seat. Everybody was quiet, even Mrs Muranda remained quiet for a moment, and I knew straightaway that I shouldn't have called her that name, but it was too late to take it back.

'What are you saying Daniel?' She got up from the front of the class and stood right in front of me. 'Who is going away?' she asked.

'I am,' I said.

'Who told you that?' she asked.

'We're all going away.'

'Where is it you're going?'

At that point I realised that I had already said too much, and

that I shouldn't say another word. She asked me over and over in front of the whole class where I was going and who was taking me, and I said nothing. She got tired of asking me, sat back down again and carried on with the lesson as though nothing had happened, and all the children worked more diligently than they had ever worked, and not one lead from one pencil was broken. I just sat there with my arms folded, unable to do any work because my pencil was still lying somewhere on the floor where she had thrown it, and because my hands were shaking so much that I wouldn't have been able to follow the outlines of even the least significant of the country's tributaries.

For the rest of the day and night, I had that pang in my stomach that you get when you know you've done something that you shouldn't have done. I hardly ate a thing that night, and went off to bed early. I always went to sleep in my parents' bed and my father would carry me onto the sofa in the living room once they were ready for bed. I lay there and prayed that we would leave that very night. I prayed so hard that I even had a dream about it. In my dream the man who was driving the meat truck to another country came to the door to take us away, but I was half asleep and couldn't get out of bed. My mother kept calling me saying that if I didn't get dressed they would go without me, but I just couldn't do it of my own accord, and in the end they left without me.

I was still in my parents' bed when I woke up the next morning, and I knew that something was wrong. My parents had gone for real, they had left just like they had in the dream, and they didn't even have time to take their coats or their hats, or to say goodbye and I never saw them again. Someone had come for them in the night and I knew it was because of what I had said to Mrs Muranda in the class, I knew that she must have told her husband and that he had arranged for them to be taken away, and that I would never see them again. My grandfather wouldn't tell me where they'd gone, or why they'd gone. He was as miserable as I was, and he refused to talk about it at all, and I never told him that I had opened my big mouth in front of the whole class.

Mrs Russo had not been exaggerating; the streets were almost deserted just as she'd said. The few cars that we saw that day went faster than usual, shut tighter than usual, as though it was about to rain, as though something was about to happen.

Mr Russo was taking us to the Grand Hotel for lunch. He wouldn't tell us where we were going until we were standing right in front of it, in the pretty square that the hotel over-looks, which is full of little kiosks where you can buy news-papers and cigarettes, and where old women sell flowers in the summer and chestnuts in the winter. In the day old men sit on the benches in the square, and teenagers with nothing better to do gather at night, and in the very centre is an equestrian statue of the founder of the city under which people arrange to meet. But all the kiosks were closed that day, they were stripped bare of the newspapers and magazines that are nor-mally stuck to the windows, and there were no flowers, no chestnuts, no old men, and nobody was waiting to be met under the statue in the centre.

Mrs Russo had linked arms with me as soon as we left their flat and she protested all the way to the hotel, pointing out how quiet everything was and how few people there were and how she had been right all along. 'Now he can see with his own eyes that everything is closed,' she said.

But Mr Russo was determined to keep his promise, he dismissed what he could see with his own eyes, saying that it felt like nothing more than a Sunday when the shops are closed and not all of the buses run, and he insisted that he knew of this place that was open every day of the year, and he would bet all the money in the world that it was open on that day.

'You don't have all the money in the world to bet,' said his wife to me and to herself.

All the people who were missing from the streets seemed to be in the hotel that day, there wasn't a single table free in the vast dining room that could be seen from the lobby, it was packed with people eating, talking and smoking all at the same time. You could hear the sound of knives and forks crashing on plates as if they were thrown down deliberately, and you

could see smoke rise up from cigarettes, floating slowly towards the ceiling, which was so high that the smoke would disperse long before reaching it. Chandeliers hung from the ceiling, too many to count, they had candles all around them, which were not really candles, but sticks that were made to look like candles. They had little light bulbs on the top made to look like flames, but really they were powered by electricity just like any other light bulb.

'Have you gone completely mad Edgar?' said his wife, 'we can't afford to eat in this place.'

Mr Russo was looking around at the grandness of the hotel, smiling to himself in satisfaction and nodding his head. 'I told you we would eat like kings,' he said, still looking around him in wonder.

The waiter who approached us was tall and thin and had a beard that was too sparse to hide the blotches and the bumps on his skin. Mrs Russo and I stood behind her husband and once again linked arms.

'Can I take your room number?' He wore a white shirt that was half tucked into his trousers and half out, with one hand he poked some more of the shirt inside his trousers, but he did it carelessly without looking, and he pulled as much shirt out as he had tucked in. In the other hand he held a menu that looked like a book.

'We're not staying here,' said Mr Russo, 'we just want to eat here.' He took off his hat and held it against his chest.

'I'm afraid that we're only serving people staying in the hotel.' He spoke fast and mechanically.

'That can't be true, I've eaten here many times before without being a guest.'

Mrs Russo's whole body seemed to choke at that. 'When did he ever come here?' she said to herself.

'I'm very sorry sir, but this is one of the few hotels that's still open and we can't serve everybody in the city.' He brought the menu that he was clutching up to his chest in the same way that Mr Russo had brought the hat down to his. 'Perhaps in a few days things will be back to normal.'

'I knew there was something this morning, I told you, you

couldn't even buy a loaf of bread in the shops,' said Mrs Russo, relieved that she had been right all along and that they wouldn't have to pay all that money just to eat there.

'What is going on?' said Mr Russo.

'Surely, you must have heard about the earthquake,' said the waiter.

'Has there been another one?' asked Mr Russo.

The waiter looked at Mr Russo in disbelief. 'You must be the only people who haven't heard.'

'Well, what is it?' he said. The waiter seemed to be purposely keeping us on tenterhooks.

'The scientists have predicted another earthquake for the next few days.'

'I knew it.' Mrs Russo looked worried all over again, she looked up at the ceiling and at the walls either side, as if she were checking for cracks. 'I knew something wasn't right, I've been saying it all along, come on Edgar let's get out of here.'

'They don't know for sure,' said the waiter, 'but you've probably noticed that a lot of people have already left the city.'

'Of course we've noticed, there are more stray dogs on the streets than there are people,' said Mrs Russo.

'They can't know for sure, how can they know?' said Mr Russo.

The waiter shrugged his shoulders and held out one of his hands that was clutching at the menu, face upwards towards the ceiling as though he was waiting for a tip.

'So what are you still doing here, and what are they doing here?' Mr Russo used his hat to point, first to the waiter, then into the dining room.

'Someone has to look after the people who are staying here, a lot of them are scientists from abroad, and they leave big tips. Anyway, to be quite honest with you, I can't see how they can predict this one when they didn't predict the last one.' He kept his voice down to say this, and Mr Russo turned his head slightly so that the waiter could speak into his ear. 'They can't even agree amongst themselves.'

'No one can predict the will of God,' said Mrs Russo, clutching my arm even tighter.

'I wouldn't be serving at tables if I thought there was going to be another one.' Mr Russo nodded over and over at what the waiter had said.

'Come on Edgar, let's go,' insisted his wife.

'Well that's good enough reason for me to celebrate,' said Mr Russo ignoring his wife, 'you sure you can't squeeze us in for lunch?' The waiter shook his head smiling, 'Or a drink at least?'

'Oh yes, you may drink at the bar on the other side of the dining room.'

'Let's go,' said Mr Russo.

'He's definitely lost his mind,' said Mrs Russo who took a little while to start following the waiter to the bar on the other side of the dining room.

The bar was just as busy as the dining room we had just walked through, but the tables didn't have tablecloths or cutlery or napkins. The people were drinking but not eating, and it was women who waited on the tables and not men, and it was mostly men who sat at those tables and not women. But the room was just as grand, the smoke from the cigarettes had to float just as high to get to the ceiling, the chandeliers were just as numerous, and they gave out just as much light as the ones in the other room.

I was no longer hungry, I had that pang in my stomach that you get when you're told that there is going to be another earthquake. We were shown to a table and a waitress came to take our order immediately, she had long fingernails that were painted black, and she looked at them the whole time that we were deciding what to order. Mrs Russo asked for coffee but her husband insisted that we take a bottle of wine and three glasses so that we could toast that it wasn't to be the end of the world after all.

'Wine on an empty stomach? They'll have to carry us home,' said Mrs Russo but the indifferent waitress was already making her way to the bar to fetch the bottle of wine and it was too late to call her back.

Mr Russo filled the glasses almost to the brim, he raised his own glass over the centre of the table and we did the same, 'To the end of the world,' he said.

'Don't say that Edgar, you're tempting fate,' said his wife, who seemed to disapprove of everything he did that day.

'The world's not going to end just because I said those words.' His raised glass descended a little.

'Let's drink to Daniel instead.' We all raised our glasses and drank to me.

Everyone was so calm that day, sitting and drinking and eating and smoking, when above our heads were chandeliers that had been dangling there for a hundred years or more, and they could surely not withstand another earthquake. Mr and Mrs Russo looked the other people in the bar up and down, looking out for the prostitutes who were courting customers in the bar on that day even though the scientists had predicted an earthquake. The waitress couldn't stop looking at her black fingernails, the waiter with the beard thought only of his tips, and all I could think about were the chandeliers that hung above our heads. I watched the beads of crystal glistening in the light from the little bulbs waiting for them to start swaying before the whole thing came crashing on our heads.

'What's so interesting?' Mr Russo spoke as he filled his glass to the brim once more, his wife looked on, starting the long count of glasses of wine that he would consume that afternoon.

'What if there is another earthquake?' I said.

'That waiter has more sense than half these scientists, how can they predict the next one when they couldn't even predict the last one?'

'No man can predict the will of God, Daniel, even if he is a scientist,' said his wife once again, placing her glass on the table and leaning back in her chair. 'God created the scientists the same way he did everybody else, no better no worse.'

'But what if they're right?'

'You should drink more of your wine and forget about the scientists and the earthquake.' Mr Russo put his elbows on the table and clasped his hands, one of them in the other, as though he was about to pray, but instead they served him as a headrest.

'So why has nearly everyone evacuated the city then?'

'They'll be back,' he said, 'and I bet they'll feel quite foolish too, that's my personal prediction.'

'I can never forget about the earthquake,' I said, 'I lost all my family in the last one, my mother, my father and my grandfather.' Mrs Russo took hold of my hand, it felt cold from the cool glass that she had been holding. 'I joined the volunteers and helped to take people out from under the rubble.'

'You poor thing,' said Mrs Russo as she held my hand even tighter, and with her left hand she awkwardly raised the glass to her mouth, it trembled in the air as though she had never used that hand before.

'And if there was another earthquake, I'd want to be here to help, the way I did the last time.'

Mr Russo kept filling my glass up to the brim, and I kept emptying the contents into my mouth, but instead of making me forget about the earthquake, it made me think of it even more. I told them all the things I could remember about that time, about being at the circus, about saving the woman who was trapped under the pole, and about finding my home empty when I got back. My words became slurred and difficult and I didn't say things in the way that I meant to say them, yet still he filled my glass and I emptied it. Soon enough the bottle was finished and Mr Russo called the waitress over for another, and Mrs Russo protested in vain and continued to make a note of every glass that we drank, and every penny that was spent.

It was no longer daylight outside, the lights from the chandeliers looked hazy and indistinct, and seemed to flicker as though they were candles after all. I stood up and weaved my way around the other tables to the toilet, concentrating hard on each step that I took, as though the wine had made me forget how to walk. The door to the toilet was heavy and wouldn't budge when I pushed it, a man standing behind me who was in more of a rush to get in than I was, also placed his hand on the door, his fingers were short and fat like the fingers of a dwarf and his hand only reached halfway up the door, but it was his strength and not mine that forced the door open.

He went into the cubicle and I stepped up onto the raised urinal that was white and made of porcelain just like the sink, the little gutter at the bottom was full of cigarette ends and little tablets of disinfectant, that had long since lost their shape and most of their scent. I watched the little current in the gutter as it dragged the cigarette ends further towards the hole into which everything flowed and tried to gather my thoughts, then I washed my hands in the cold water that came out through the tap marked hot.

The door was much easier to open from the inside than it had been from the outside, and it would have opened with far less effort, but I pulled at it with all my strength, and the metallic handle crashed against the wall and made such a noise that it caught the attention of everyone sitting nearby. They all looked up from their drinking and their smoking to see what had caused that noise. Of all the faces that looked up to see what had happened, the first one I saw was Marina's.

Marina was sitting at a table in a corner on her own, a handbag rested on the table as though she had just arrived, or was about to leave, or just that she wanted everyone to see it. The handbag had a thick gold chain for a strap that was curled up like a dead snake, next to it were two leather gloves, both of them clenched into fists, as though there were still hands inside them. Marina was wearing a pink dress that was the most beautiful dress I had ever seen; the cuffs were black and the collar was black and the buttons were the colour of gold, they matched the chain on her bag. I had never seen her look so well; her hair was longer and lighter than before and she wore earrings shaped like zigzags, that looked like streaks of lightning falling from her ears. She looked away as soon as she caught my eye, but I made my way straight to where she was sitting.

'Have you heard the news about the earthquake Marina?' I said to her as soon as I reached her table.

'Of course I have, everyone has.' She shot a look up at the ceiling.

'What are you still doing here then?'

'None of your damn business.'

'Half the city has already been evacuated, you should leave while you still can,' I said to her.

'Why don't you evacuate the city if you're that worried about it,' she said in a raised voice as though I had insulted her in some way, her zigzag earrings swung as she spoke.

'I can't leave the city Marina, I have to stay here and help people like I did after the last earthquake.'

'Well I hope you have better luck with that than you did the last time.'

'Marina my luck has come back to me again,' I said.

'You never had it in the first place.' She twisted the catch on her handbag, opened it and looked through all the things that she had inside as though she didn't really know what she was looking for.

'I swear to you Marina there are things that have happened to me lately that you wouldn't believe.'

'I don't believe a word of what you say to me anyway.' She took out a handkerchief from her handbag, opened it up and blew her nose half-heartedly.

'Honestly Marina, my luck has changed, even Mrs Roman has noticed it.'

'That old bag doesn't even know what day of the week it is,' she said.

A small man appeared from nowhere and swiped the gloves from the table, as though I was about to steal them. He put them on his hands as he looked me up and down. His fingers were thick and dwarfish, and I realised that it must have been the same man who had helped me open the door to the bathroom. He was wearing dark glasses as though it was day and not night, and he was outside and not inside, like a blind man.

'Who's this?' He asked in a voice that was more like a child's voice than the voice of an adult. 'Just another person in a panic about the earthquake,' she said. 'Let's sit somewhere else, we're too close to the toilets here, and they stink more than ever.'

'That's because everyone is nervous about the earthquake,' I said.

Marina stood up and even she towered above the little man,

she picked up her handbag and went to another part of the bar without even saying goodbye.

'Just wait your turn like everyone else,' said the little man before following Marina to another part of the bar, his body rocking from side to side as he walked because one leg was shorter than the other. I sat down at the table where they had been, the red leather seat still warm from Marina's backside, and I could still see her as she sat down at another table in a corner. The little man's gloved hands played with Marina's zigzag earrings and her hair, and he didn't even stop or look up at the waitress when she came to take another order for more drinks, he just muttered something and carried on with what he was doing. He brought his mouth so close to her ears that he could have swallowed them whole if he'd wanted to, and Marina giggled because it must have been ticklish having his hot breath right on her ears.

When the drinks came his hand slid down to her breast and his short thick fingers massaged her, gently at first then harder, right there in front of all the people, although no one seemed to be bothered by what was going on because they were in the bar of the Grand Hotel and this went on all the time. She threw her head back in pleasure and I got excited just by watching her. He took her hand and moved it to between his legs so that she could take his cock and do with it what he was doing to her breast, and under the table my hand moved towards my own cock which had hardened almost the moment I saw her, and I started doing the same thing as if it was her hand and not mine. The man took the gloves off with his teeth, and his naked fingers moved down to her legs, under her skirt and you could see from her face when they reached between her legs, her head tilted back and her eyes closed because she liked to be touched there so much. And I just couldn't help watching her and touching myself under the table and I would have come right there in my trousers in the bar of the Grand Hotel, if Mrs Russo hadn't suddenly appeared before me.

'What are you doing sitting here Daniel?' she said. 'You look very odd, are you all right?'

'I don't feel very well,' I said.

'I thought as much.'

'My stomach hurts.' My hand slid up from between my legs up to my stomach and clutched it.

'Of course it hurts, you've not had anything to eat, I knew this was a bad idea, I think Edgar really has lost his mind. We're going home right now and I'll make us all something to eat before we collapse from hunger.'

We walked to where her husband was sitting. 'Come on Edgar, enough is enough.'

'Where was he?' he asked.

'He was slumped over a table by the toilets.' Mrs Russo took the empty glasses and the bottle back to the bar as if she was clearing up in her own home. 'That's enough wine and enough of wasting money.' I put my coat on and followed them through the dining room out into the fresh air of the street. Mrs Russo linked arms with me just as she had done on the way there, and her husband swayed towards us and away from us uncontrollably, crossing the streets without looking one way or the other, like the stray dogs that roamed the city.

Mr Russo fumbled for the key outside the door to their flat. He could hardly see what he was doing because his hat was tilted forward on his head, almost covering his eyes. He took it off his head and put it onto mine. Still he couldn't find his key, he leaned against the wall as he searched his pockets, pulling out bits of paper and coins and the little balls of fluff that build up in your pockets all by themselves, and finally he found the key. 'Thank God for that,' said his wife who was finding it less and less amusing.

But then he couldn't get the key in the door, he couldn't even get it near the keyhole. He scratched the paintwork of the door as he dragged the key along, hoping that eventually it would sink into the keyhole, but it never did.

'Give it to Daniel,' she said, 'you're beginning to get on my nerves.'

Once we were inside the flat, he stood in the hall, trying to take his shoes off, balancing himself on one foot as he took the

shoe off the other foot, and you could see that he was going to topple over because he couldn't stay standing on two feet, much less on one.

'Be careful Edgar.' Mrs Russo shook her head from side to side, but Mr Russo was already leaning too far in one direction, and he fell to the floor without even taking off one of his shoes. 'Are you all right?' asked his wife.

'Never better.' He sat up on the floor with his back against the wall. 'Now help me take these damn shoes off before I end up killing myself.'

I took hold of one foot and his wife took hold of the other, and we pulled so hard, that when the shoes came off his feet we almost ended up on the floor ourselves.

'These are so much bigger than the ones you gave me.' I said, and put the shoe on the floor so that I could compare it with the one that Mr Russo had given me. 'How could you ever get these on your feet?' I pointed to the shoes I was wearing, which he had given me.

Mr and Mrs Russo looked at each other. 'Those aren't Edgar's shoes you're wearing.' Mrs Russo took off her own shoes and stepped into the slippers that she had stepped out of earlier that day.

'Whose are they then?'

'They're yours now Daniel that's the important thing,' she said.

'They belonged to Victor,' said Mr Russo, who was still sitting on the floor, 'he lived here before you, in the same room as you, and everything about you is the same as him, that's what I've been trying to tell you Daniel.' Mr Russo held his arms up in the air and his wife took one of them and I took the other, just as we had done with the shoes, and we pulled him up off the floor.

'It was as if God had brought you to us in his place,' said Mrs Russo as she hauled her husband up from the floor. She then went into the kitchen and started making food from the little she had in that day. Mr Russo and I sat down at the table in the living room and she came in and out from the kitchen to lay the table and bring in the bread, then glasses, and then

spoons, and not one of us spoke another word about it until the bowls of steaming soup were on the table.

Mr Russo took a slice of bread and broke it into little pieces, which he then dropped into the soup, and we all began to eat; our spoons clattered against the bowls and all three of us slurped our soup because it was so hot.

'Where is he now?' I asked.

Both of them stopped eating. 'We don't know where he is,' said Mr Russo.

'Something terrible has happened to him, I know it has.' Mrs Russo dropped her head and looked down at her bowl. 'He left the house one day and we never saw him again.'

'Didn't he say where he was going?'

'He never said anything,' said Mr Russo, 'he lost his tongue in the earthquake, he used to write on little bits of paper to tell us things, I have a whole drawer full of them.'

'I honestly thought it was him when I saw you at the station,' said Mrs Russo, 'until you spoke, don't you think that's strange Daniel?'

I shrugged my shoulders and let my spoon slide into the bowl of hot soup.

'I can't eat any more either.' Mrs Russo pushed her own bowl away from her and took a deep breath.

Mr Russo continued bringing spoonfuls of soup up to his mouth mechanically. 'It's more than strange Daniel, you two look exactly alike.' He took another spoonful. 'Everything about you is the same, everything, apart from the fact that he couldn't speak. And how could all this be a coincidence?' Another spoonful. 'The shoes, the shirt, everything. He was the one who broke the china doll, you know, and you did exactly the same thing, he lost all his family in the earthquake just like you did. It's history repeating itself, that's what it is.'

'It's true Daniel, it's as if you two were the same person, you're kind and gentle and you wouldn't hurt a fly, and he was just the same as that, if only you could have met him.'

'I'm telling you this is more than just a coincidence, this is something out of the ordinary, and if you aren't careful the same thing that happened to him will happen to you.'

'Maybe something good happened to him,' I said.

'Maybe,' he said, without conviction.

'I don't think that for a moment, I know something terrible has happened to him, I know it as if he were my own child.' Mrs Russo stood up as soon as her husband had taken the last spoonful of his soup, she picked up the bowls and took them into the kitchen. There were three circles on the tablecloth where the bowls had been resting, crumbs scattered all around the circle in front of Mr Russo, from the bread that he had ripped into little pieces and dropped into the soup. He swept the crumbs with the side of his hand and made a little pile of them in front of him, the way you do when you sweep the floor. He swept them all into the circle and he began to tell me all the things about Victor that were the same as me.

Victor was the village idiot. I had thrown him into the river and now I was sleeping in his bed, wearing his shoes, his clothes, and doing the exact same things that he had done. I just couldn't get away from him. I tried to leave that very night after Mr and Mrs Russo had gone to bed but the front door was locked from the inside. They hadn't been capable of opening the door to get in, but they had managed to lock it from the inside without any fuss. I looked for the key, but it wasn't on the table, on the floor nor on the side, it wasn't anywhere. I looked through the pockets of Mr Russo's coat, he had a handkerchief that was dry and stiff and stained with blood from all his coughing, and he had some money, but no key. I took the money and stuffed it into my pockets.

I lay on the bed and told myself I wouldn't be sleeping that night, I'd wait until someone let me out in the morning and I would get as far away from there as I could. I promise you I felt sick in my stomach for what I had done. Perhaps Mr Russo had been right after all and whatever happened to Victor must now happen to me. I prayed to God that the scientists were right and that the waiter was wrong, and that the earth would start to move and that all the buildings in the city would collapse so that I could pull people from the rubble, and make up for throwing that man into the river. I changed back into my own clothes, lay on the bed and kept

my eyes open, just in case anything happened in the night, but after awhile I closed one eye then the other, just for a moment, just so I could rest them, and I fell asleep even though I said that I wouldn't.

Eight

Victor had been at the circus on the day of the earthquake, just like me. He had seen the bears and the dogs and the tigers perform their tricks, he had seen the clowns stumble and fumble and fall to the ground, and he had laughed so hard that his stomach almost hurt, just like mine had done. Then the earth started to shake, and he had seen everything before him descend into chaos. He saw the clowns slip and slide running for their lives, as though it was a part of their act, he saw the tigers maul the children who were sitting at the front. He saw the bears running on all fours towards the nearest exits still wearing hats on their heads, and he had seen the ponies run round and round the ring as though that was the only trick they knew.

He was sitting on one of the rows of wooden seats just like I was, further towards the front than me, and he started running towards the exit as soon as he realised what was happening. But on the day the earthquake struck, it was the animals who took priority and not the spectators; the bears and the tigers and the monkeys would have torn anyone apart who had stood in their way, and everyone else had to wait their turn, standing well away from the path of the circus animals. So Victor was trapped inside the tent like everybody else.

One of the smaller wooden poles that supported the canvas above our heads came loose as the earth shook beneath it, people ran in all directions to try and get away from it, but there were so many other poles and wires and cables falling all around us from all the equipment high above our heads that he didn't know where to run. Victor never got away from it in time, the pole only brushed against him as it fell to the ground, but it was such a shock and it was so heavy that the force of it made him bite off his own tongue; it was left dangling from his mouth half on and half off, and they had to cut the whole thing away because there were so many casualties that night,

and because it was bleeding so badly that it would never have healed by itself. That's how Victor had lost his tongue, and that's why he couldn't speak.

The block of flats where Victor lived with his family collapsed in the earthquake, the top floor was completely intact, but all the other five storeys had been squashed underneath it. He only recognised it from the washing that his mother had left hanging on the line at the very top of the building earlier that day, the clothes still stretched from one end to the other. Some of them were still damp, and they flapped in the breeze as though nothing had happened, except that the top floor had become the ground floor, and the clothes that hung from the line at the very top of the building were now perfectly visible from the street, and somewhere underneath were Victor's family and so many other people who had the misfortune of being in when the earthquake struck. The whole area was later bulldozed to make way for the new parliament building complex that they say will be one of the biggest buildings in the world.

Victor had nowhere to go, he slept in the train station and sold pens to the passengers on trains and to the people at the station. He boarded the waiting trains, walked up and down the corridor and entered all the compartments, laying bunches of pens wrapped in elastic bands on the lap of every single passenger, attached to those pens was a little note explaining that he had lost his tongue and his family in the earthquake. When he had reached the end of the carriage, he went back to the very beginning and entered the compartments all over again, taking the pens from their laps, and putting them back into the bag that always hung from his shoulder. He'd get off at the first station and take a train back, along with all the other vendors who sold puzzle books, and biscuits and crisps and drinks and anything that passengers on a waiting train might require for the journey ahead. That's what he did all day long, and he just about made enough to keep himself alive.

Mr Russo saw him one day at the train station after Victor had laid a bunch of pens on his lap, and he took pity on him because he had no tongue and he couldn't speak. He bought

some of his pens and invited him to come and eat at his house. Victor scribbled down all the answers to Mr and Mrs Russo's questions on the scraps of newspaper and the sweet wrappers he had found on the station floor, and which he had crammed into his pockets just for the occasion. On the third night that he came for dinner, Mr Russo gave him a key so that he could come and go as he pleased. He would live there as though he was their son, and so that he would look after them when they could no longer look after themselves, just like Mrs and Mrs Roman had wanted me too. Victor had lived in their apartment ever since, until one day, just a few weeks before, he hadn't come home and Mr and Mrs Russo never saw him again. That was when he began to follow me night and day, and only I knew for sure that they would never see him again.

I was woken by a tapping at the door. I had heard it in my dreams, and I could still hear it when I awoke. I knew it was morning because there was light coming in through the curtains, and because I could hear the pigeons cooing and shuffling along the gutter above the window. The tapping stopped, the door opened and Mrs Russo came into the room holding a tray; the china cup, the saucer and the spoon that were on the tray clinked against one another delicately and didn't stop until she laid the tray on the bed.

'You're not even under the covers,' she said. Mrs Russo looked old and strange that morning, her hair was dented on one side but not on the other, because of the way that she had rested her head on the pillow in the night. Her face was shiny from all the creams that she rubbed into her skin before going to sleep, some of the cream still sat on her face unabsorbed, around her nose and around her eyes, on one side but not on the other side because of the way that she had rested her head on the pillow in the night.

'I didn't sleep all night.' I sat up carefully in the bed so that the coffee in the cup on the tray wouldn't spill.

'I hardly slept myself.'

'I'm leaving today Mrs Russo, as soon as I drink this coffee.' I swung my feet so that my shoes hung off the side of the bed,

but they had already soiled the covers and she had already noticed it.

'But where will you go?'

'I want to help people if there is an earthquake, like I did the last time,' I said.

'But there hasn't even been an earthquake, and there isn't going to be one.' Mrs Russo moved over to the window with great enthusiasm, the belt that clung to her dressing gown trailed after her. 'You can see for yourself if you like.' She pulled back the curtains as though she was inaugurating a monument, the curtain rings scraped against the metal rod, and the dim grey morning light came into the room. 'It's exactly the same as it was yesterday.' The window panes were soaked with the moisture that had gathered there in the night, and you couldn't see a single thing through the glass, the city could have been razed to the ground for all we knew. Mrs Russo wiped the pane with her hand and then wiped her hand on her nightgown, but still you could hardly see outside. 'Come here and you'll see that I'm not making up stories.'

I stood up from the bed and moved over to the windows. She stopped wiping the glass, and decided to open the windows as far as they would go. 'Now you can see for yourself,' she said as she flung them open. The pigeons that were perched on the gutter above the windows were startled by the sudden move-ment below, they flapped their wings in distress and hovered in midair before flying away, leaving a trail of small white feathers behind them. Some of those feathers floated slowly down to the ground like snowflakes in the wintertime, and some of them drifted in through the open window into the room.

The city was just as we had left it. I saw the cranes that tower above the building site of the new parliament complex, I saw the chimneys of the factories along the river which were no longer sending out white smoke that looked like clouds. I saw the church spires still standing erect as they always had, the high-rise apartment blocks which would be the first to go if there was an earthquake, and I saw the pigeons that got smaller and smaller as they flew further away from us. The sky

was grey and still, and everything looked exactly the same as it had the day before because the earthquake hadn't come in the night.

'Maybe it will happen today,' I said.

'I wouldn't hold my breath if I were you Daniel,' she said, 'these scientists don't know anything, they don't even know when it will happen, it could even be next year, or it might never come at all, and everyone who has left the city will feel foolish for leaving in the first place.'

Suddenly a little white feather appeared in front of her, it floated so close to her face that she had to cross her eyes in order to see it. The moment she saw what it was, she unfolded her arms and waited to launch herself onto the feather, like a cat chasing a fly. She clapped her hands in midair in front of my face to catch the feather. 'Now I have to close my eyes and make a wish.' She moved closer to the window, closed her eyes and held them closed so tightly and wished so hard that little lines appeared above her eyebrows. She opened her eyes again and blew the feather from the palm of her hand like she was blowing a kiss to a distant lover. The little white feather was launched out from the window and into the air outside, where it began its slow descent towards the ground. 'I wished that you could stay here forever with us.' She closed her dressing gown, folded her arms over it once more, and watched the feather descend onto the street like all the others had done.

'I can't stay here Mrs Russo, I have to be ready to help like I did the last time.'

'All my wishes have come true so far.' She closed the window. 'I wished that Victor could come back to us and then I saw you at the station, and last night I wished that there would be no earthquake in the night, and you have seen for yourself that there hasn't been one.'

'But I have to be prepared in case there is one.'

'What if something terrible happens to you and you never come back?' Mrs Russo took my hands in her own and she pressed them against her face on the side that was still shiny from all the creams that she had rubbed onto it the night

144

before, then she brought them down and held them out in front of her. 'Look at your hands, they're small and delicate just the same as Victor's hands, and your eyes are the same, and your nose, everything is the same, and I know something terrible will happen to you, just as it did to him, I know it will.'

'I can't stay here.' I pulled my hands away from her.

'No one will keep you here against your will Daniel, now drink your coffee before it gets cold.' She moved over to the bed, and picked up the cup and the saucer. Her hands were unsteady and the coffee spilled from the cup onto the saucer. Before taking the cup from her, I reached down and took hold of the belt from her dressing gown that was still trailing behind her and we exchanged the cup for the belt.

'I've been trying to reach for that all morning.' She tied it around her waist and left the room, dragging her slippers along the floor.

When Mrs Russo came back into the room, she looked like a different person, she had taken off the dressing gown and put on the red woollen dress which she had been wearing at the train station the first time that I saw her, she had wiped off the cream which had made her face look so shiny and her hair was even on both sides.

'This is for you.' She held something in her hand.

I stretched out my hand to take what was in hers because I thought it was the key, but it turned out to be money, I pulled my hand away at the last moment as though I wasn't going to take it.

'Take it,' she said, 'don't be shy, you're proud and stubborn and you've got a kind heart, just the same as Victor.' She held out her other hand, and this time it was a key, she kissed it for good luck and gave it to me. 'You can come back here whenever you like.'

I took the money and the key and walked down the stairs that spiralled all the way down to the front door. Mrs Russo leaned over the railings and watched me as I descended.

'Be careful Daniel.' She called out to me.

'Don't worry, I will.'

Then I heard her close the door before I got to the bottom, and the sound of it closing echoed through the building. I stepped out into the street, and looked around, like a dog that is finally let out after being locked in all day. Mrs Russo hung her head out of the window of the flat, I waved at her but she didn't wave back, she just watched me as I walked further away.

The train station was as quiet as a graveyard; there were no guards, no whistles and no announcements, the only people in the station were the children and the beggars who lived there all the time. Stray dogs dozed in the middle of the station, curled into themselves, more like cats than dogs, right in the middle of the station, as though it had been abandoned for ever, as though they had forgotten that only a few days before, they would have been trampled to death if they had sat on that spot even for just a moment. Other dogs combed the station floor, which was covered in rubbish everywhere you looked.

The huge clock above the arrivals and departures board was still stopped at twenty minutes past eight because the earthquake that they had been predicting had not come as they said it would.

Suddenly the sleeping dogs uncurled themselves, and the other dogs stopped looking for food and doing whatever they had been doing; they all listened out for something which in the very beginning only the dogs could hear, one of the dogs started barking, and soon they were all barking.

It was a train pulling into the station that had upset the dogs, and it was even more unexpected than the earthquake because there were no announcements and there was nothing on the board to indicate that it was on its way. The rumbling noise made by the engine and the terrible squeaking of the brakes was so loud, and the place had been so quiet beforehand, that some of the dogs ran away and the ones that stayed behind stopped barking altogether. The train came to a standstill, the doors opened, and people stepped carefully onto the platform, as though normal life was about to resume.

Suddenly the blind could see and the lame could walk, and all the children and the beggars rushed forward from all corners

of the station with their arms outstretched towards the passengers stepping off the train, and now that the train had come to a complete halt, it was their pitiful pleading that could be heard above all other things. In this sudden chaos, I was mistaken for one of the passengers and was surrounded by beggars in an instant, they all held out their hands and pleaded with me to give them food or coins or something, each one more desperate than the last. They hounded me out of the station, into the square in front, and followed me as far as they dared, repeating the same words over and over. I walked away from them as fast as I could, leaving most of them behind, but one of the children was so persistent that he followed me long after all the other children had given up. He followed me all the way to the Grand Hotel, he walked as far as the stairs that lead to the entrance but he didn't dare come inside, he was left standing outside holding out his dirty little hand.

Inside the hotel it was lunchtime, you could smell the food all around as it wafted in from the kitchens to the restaurant and finally to the lobby in which I stood. The doors of the lift opened and closed taking the smell to the other floors in the hotel.

Marina was the first person I saw in the bar on the other side of the restaurant, I saw her through all the people sitting there drinking and eating and through the smoke that rose from their cigarettes, and all the waiters coming and going, but she never saw me. She was in exactly the same spot that she had been in the day before, near the toilet, wearing exactly the same dress. Again she was there with a man; not the dwarfish man from the day before, but a man who you could tell was taller and leaner even though he was sitting. His long arm stretched across her shoulders so that his fingers combed her hair on the other side, and his face was buried in her neck as if he was feasting on her flesh.

I weaved my way through the tables in the restaurant and took a seat in the bar with my back to Marina so that she couldn't see me, but I could see everything she did in the huge mirror above the bar in the old-fashioned gold leaf frame that was chipped here and there so you could see the white plaster that lay beneath it. The man who was sitting with

Marina whispered something into her ear, she laughed out loud and threw her head all the way back, as though she was looking at the cracks on the ceiling. He fed more hilarious things directly into her ear so that no one else would hear, and every single thing that he said to her was funny enough for her to throw her head all the way back, as if it was the funniest thing she'd ever heard.

It was Daniel Ferrer who was sitting next to Marina, and it was he who whispered things into her ear. He looked exactly the same as he always did; his hair was blond and greasy and combed back over his head the way it always was, and when he laughed at his own jokes, you could see his teeth crooked and rotten, they were so bad, that you could see them reflected in a mirror from the other side of the room. His shirt was like all the shirts that he ever wore to work, it was grey and it was dirty and the material was so thin that you could almost see right through it. I must have seen that same shirt a thousand times, I know it as well as I know the clothes that hang in my own wardrobe, and I had that pang in my stomach that you get when you are so full of hatred that you're not sure you'll be able to control it.

Mr Ferrer sat next to Marina with one arm curled all the way around her so that she couldn't get away even if she'd wanted to, the other arm was under the table and even though I couldn't see what he was doing I knew that his hand was between her legs moving up her skirt as far as she would let him, and I knew that she would let him because that is exactly where she liked to be touched. Even though I hated him with all my heart, I got excited just by seeing all this reflected in the huge mirror in front of me, and imagining his fingers there between her legs, where it's hairy and moist and where she loves to be touched.

He whispered something else in Marina's ear, and then he stood up from his seat and walked through the restaurant to the main entrance. She watched him as he made his way through the bar, opened her big handbag and looked inside, which is what she did when she didn't know what else to do with herself.

The beer I was drinking went straight to my head, and the chandeliers began to blur as though they had moved further away from me, and the place was loud and smoky. Marina was sitting on her own just like the day before, wearing the same dress that she had been wearing the day before. I moved over to where she was sitting and stood over her table.

'I know that man who was sitting here with you,' I said.

'Are you going to be here every day? Don't you have anything better to do?' She put her fingers through her hair and looked all around her but not at me.

'He was my boss at work.' I pointed at the chair as though he was still sitting in it.

'So what?' she said.

'He's the one who made me go back to work after the last earthquake.'

Marina reached into her handbag and opened up a little silver mirror which she held up to her face, it reflected the light from the lamp that was fixed to the wall above her head. The reflection moved restlessly on the wall behind her, and for a little while I watched the reflection and not her. 'I could have helped all those people but he wouldn't sign the form, he made me work every day after the earthquake.'

'Don't you ever think about anything else?' She was looking into the mirror so intently that she could have been talking to herself and not me. 'You should try and expand your mind.'

'I'll never forget about the earthquake,' I said to her shaking my head.

'You need to forget about it and move on like everyone else has.' She snapped the mirror shut, the reflection moved sharply along the wall before disappearing.

'How can I ever forget about the earthquake when I lost all my family?'

'You did not lose all of them in the earthquake, I know for a fact you didn't, it's just another little story you tell so that everyone will feel sorry for you.'

'I lost them all in the earthquake,' I said to her.

'You lost your grandfather, and I've never heard you say a nice word about him in all the time I've known you, so I'm sure you got over that loss pretty quickly.' She snapped her handbag shut.

'Mr Ferrer wouldn't even let me take time off to look for him, he treated me worse than anyone else, he made me do jobs that I didn't want to do, and I hate his guts.'

'What are you talking about now?'

'The man who was sitting here, I told you he was my boss.' Again I pointed down to where he had been sitting.

'Quite frankly I don't believe a single word that you say.' She stood up from the table.

'Where are you going?' I asked her. 'Is he waiting for you?'

'I don't have to tell you anything,' she said and started to leave.

'Look I have money, I can pay to go with you.' I took out all the notes in my pockets.

'So that we can talk about the earthquake? I don't think so,' she said.

'I want to be with you Marina, my luck has changed, everything has changed, I promise you.'

'You'll never change Daniel Glick you were cursed from the day you were born,' she said as she moved away.

'I hate his guts, you don't know how much I hate him,' I called after her, but she took no notice, she continued walking through the bar to the reception and I knew that he would be waiting for her and that they would go up to one of the rooms because that is what Mr Ferrer did, that's where he spent all his money, in the small rooms at the back of the Grand Hotel. And I knew that Marina would go with him because she loved money more than anything else in the world, and that is what she had become. I knew he'd fuck her in the way that I couldn't, in the way that the dwarf man had fucked her the night before and in the way that anyone who was willing to pay could fuck her, the way that I'd never been able to.

I stayed in the bar and had another few beers, and I couldn't get Mr Ferrer out of my head. I couldn't stop thinking about him whispering into Marina's ear and stroking her leg under

the table, and his fingers working their way between her legs where she loved to be touched, all the way in.

I waited for him outside the hotel just like the beggars had waited for the passengers coming off the train at the station, and the wicked things that he had done to me went round and round in my head. Finally I saw him come through the doors at the front of the hotel, with a stupid smirk on his face, he put his fingers through his hair and took out a cigarette from a packet, he lit it and discarded it at the top of the steps that led up to the entrance, then he walked down the steps leaving a fresh cloud of smoke behind him. I followed him away from the hotel in the way that Victor had followed me all around the city, and I told myself over and over that I would never go back to that office, and I kept thinking about how he had been inside Marina in a way that I had never been able to, and it all went round and round in my head.

He must have sensed that there was someone there even before he looked back, in the same way that I had sensed the same thing about the village idiot. He stopped abruptly and turned around. 'Is that you Daniel Glick?' he called out.

'I'm never going back to that place,' I shouted at the top of my voice.

'What are you talking about?'

'You'll never make me go back to that awful basement.'

'Is this what you've been doing since you left, wandering the streets like a vagrant, look at you, you're a mess.'

'I know what you've been doing in the hotel, I know what you spend your money on, everyone knows it, you're the one who's a mess, not me.'

'You can think what you like, I don't give a shit either way,' he said, and carried on walking. I had that pang in my stomach that you get when you are so consumed with hatred that you don't know what you're going to do next.

'It should have been you and not Mr Banos who died in the earthquake,' I shouted out, but he carried on walking. 'And I'm not the only one who thinks that, everyone thinks that!'

I should have left it at that and turned the other way but I

carried on following him just like the village idiot had fol-
lowed me. Mr Ferrer reached the steps that lead onto the
long footbridge that crosses the railway tracks, I followed
him up the steps and onto the bridge, and even though he
must have known I was still behind him, he never once
turned back. But as he reached the middle of the long
bridge, a train passed underneath us, and I ran towards him
as the train, which was perfectly visible through the gaps in
the planks of wood, screeched into the station. I took hold
of his jacket and with all my strength I tried to swing him
around against the railings at the side, just like I had done
with Victor on the bridge over the river, but Mr Ferrer
was so much taller and stronger than Victor and he hardly
moved from the spot.

'What the fuck is wrong with you?' He pushed me with
one hand and that was enough to send me toppling onto the
railings.

'You'll never make me go back there,' I said to him.

'You're an idiot,' he said, 'I don't give a shit whether you
come back or not.'

I rushed at him again and this time I did force him onto the
side, but he punched me in the stomach so that I froze right
there clutching it, bent double, unable to do a thing, unable to
take a single breath. He took me by the scruff of the neck
and pushed me against the railings, this time with so much
force that my head and half my body hung over the side, and I
was left staring at the railway tracks that criss-crossed beneath,
just like Victor was left staring at the currents in the river
before I threw him over. History was repeating itself just like
Mr and Mrs Russo had warned.

'I should throw you over, you fucking idiot,' he shouted
right into my ear, and he could have thrown me over if he'd
wanted to because he was so much stronger than me. 'I don't
ever want to see your stupid face ever again.' He let me go,
and continued to cross the bridge, just as another train
screeched into the station.

I ran all the way back to Mrs Roman's house, just as I had
done after I pushed Victor into the river. I ran up all five flights

of stairs and found the door to her flat already open, as though she had been expecting me, I called out her name but there was no answer. I collapsed onto the sofa in the living room and began to catch my breath. There were cups and plates and old newspapers strewn all around, but there was no Mrs Roman. Suddenly I realised that I could hear the tick-tock of the clock that had rested on the cabinet since the earthquake, I jumped to my feet and picked it up. The clock was no longer stopped at twenty minutes past eight, the second hand had started up again just like they said it would, and this time I hadn't imagined it. It was louder than any other sound, louder than the sound of my breathing and louder than the sound of any other clock that I had ever heard, and even as I ran down the stairs, two by two, three by three, I could still hear that ticking loudly and distinctly in my head, like a bomb about to go off.

The rumbling noise started after I had flown down the top two floors, and the whole building began to shake this way and that. The walls curved and twisted as if they were soft and elastic and not hard and brittle, they made squeaking noises that got louder and more frightening before cracks appeared in them, zigzag cracks that divided the walls into so many sections before whole segments of it came crashing to the ground, no longer soft and elastic. The stairs began to come away from the beams onto which they were nailed, like the keys of an old piano, so that I could hardly even walk down them any more.

Mr Russo was wrong, the waiter was wrong, and I was right, and the scientists were right, they really could predict the will of God after all. The earth shook just like it had before, it shook so violently that when I finally made it out of the building and ran out into the street I could hardly stay standing. I saw the man from the bar across the street who had also run out into the road, the glass panes of the bar shattering all around him. Then the sound of breaking glass everywhere, as though everything around us was made of glass, and was breaking at that very instant. The streetlamps leaned this way and that, backwards and forwards, like treetops in a gale,

and the walls of buildings shook and curved as if they were made of cardboard and not concrete, like the buildings in a play on the stage.

'Get away from there!' the man from the bar was shouting at the top of his voice, but you could only just hear him above the rumbling sound of the earth! 'Run!' he cried.

And even though I knew he was calling out to me, I didn't know what I was running away from or where I was supposed to run to. I looked behind me and one of the streetlamps was leaning so far that it looked like it was on the verge of toppling over, just like the poles at the circus that had fallen onto the spectators below, that had fallen onto Victor's head and made him bite his tongue off. I started to run away from it, but the shadow it cast on the ground got closer and closer as it leaned further and further towards me. I ran one way and then the other way to get away from it, but as fast as I ran, and in whichever direction I ran, I just couldn't get away from its shadow.